# Rustic Buildings & Barns

## IN WATERCOLOUR

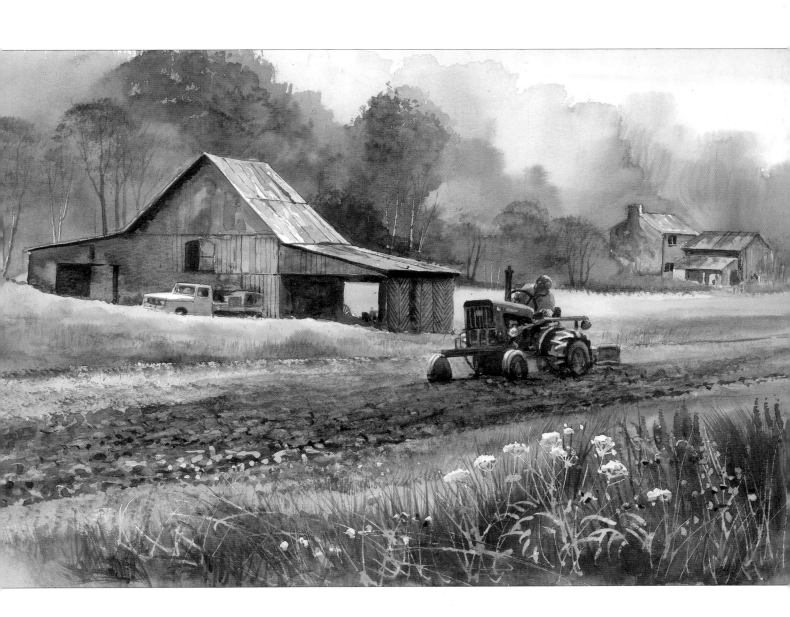

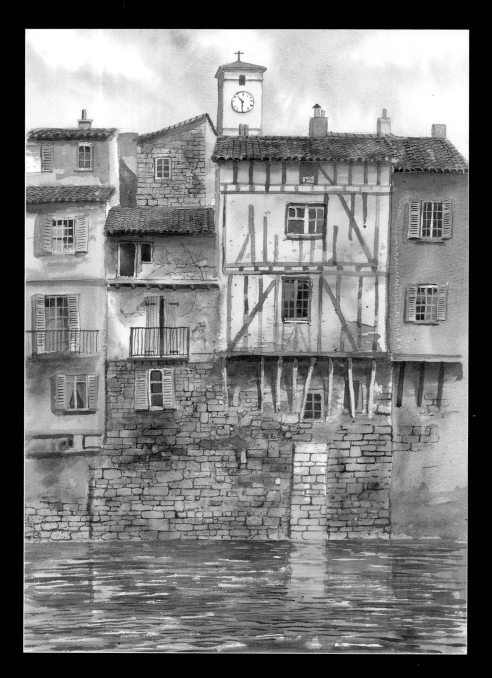

# Rustic Buildings & Barns

## IN WATERCOLOUR

### Terry Harrison

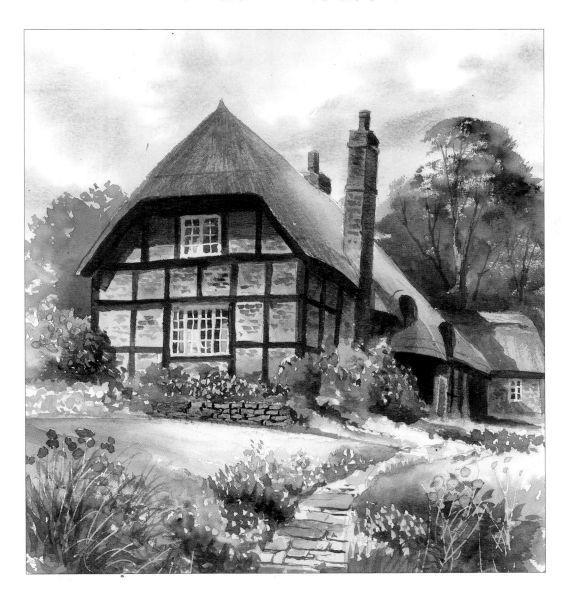

SEARCH PRESS

First published in Great Britain 2009

Search Press Limited
Wellwood, North Farm Road,
Tunbridge Wells, Kent TN2 3DR

Reprinted 2009, 2010

Text copyright © Terry Harrison 2009

Photographs by Roddy Paine Photographic Studios

Photographs and design copyright © Search Press Ltd, 2009

ISBN: 978-1-84448-342-6

The Publishers and author can accept no responsibility for any consequences arising from the information, advice or instructions given in this publication.

Suppliers

If you have any difficulty obtaining any of the materials and equipment mentioned in this book, please contact Terry Harrison at:

Telephone: +44 (0)1386 584840

Website: www.terryharrisonart.com

Publishers' note

All the step-by-step photographs in this book feature the author, Terry Harrison, demonstrating how to paint buildings. No models have been used.

Printed in Malaysia

Acknowledgements

*A section of this book was actually painted in France, so my thanks go to Paddy and Marion for the use of their barn in the Dordogne – painting in the sunshine works for me! Research and barn hunting have become quite an obsession, so thanks to my partner, Fiona Peart, for her endless patience. This is my eighth book so I know by now the importance of a good editor, so my thanks to Sophie Kersey for agreeing to yet another editing marathon!*

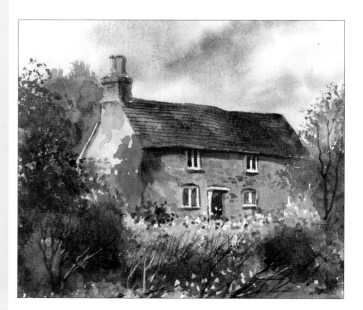

*Page 1*
HARD DAY'S WORK
*53 x 35cm (20⅞ x 13¾in)*
*This painting is also shown on page 122.*

*Page 2*
ON THE WATER'S EDGE
*35 x 53cm (13¾ x 20⅞in)*
*These rustic French riverside buildings seem close to falling in the water, each one holding up the others – all for one and one for all!*

*Page 3*
THE GARDEN PATH
*30 x 33cm (11¾ x 13in)*
*This painting is also shown on page 51.*

*Opposite*
WOODEN COTTAGE
*30 x 24cm (11¾ x 9½in)*

# Contents

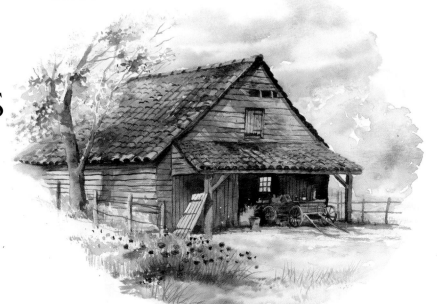

# Introduction

In my early painting years I had a few books on art: they were full of fabulous paintings by Constable, Turner and the Impressionists, but none of them told me how they did it! At school, in English lessons we were taught all about verbs, nouns, punctuation and how to construct a sentence, and in maths we learned how to add and subtract and about mathematical formulae, but when it came to art, we were told to experiment and express ourselves, but never how to do it. What I wanted was some simple explanations in an easy-to-follow format that would show me how. So I have set about compiling the sort of book I always wanted, that simply explains how to paint.

My favourite painting subject has always been landscape, but looking back over my career in art I find that many of these paintings include buildings of some kind. The scene might be a landscape but within it there would be cottages, farm buildings or barns. I am surprised at how often barns feature in my work – I must have a thing about them! In this book, I hope to inspire and encourage you to choose barns and rustic buildings as suitable subjects. I will share with you some of my experiences and techniques for how to achieve the best results when tackling buildings.

Once you have learned the basic techniques, you can develop your own style of painting. I have chosen rustic buildings and barns as the subject for this book, but the word 'rustic' could also mean a style of painting. If a roof is not quite straight or the windows and doors are a bit wonky, your style can be called rustic!

Over the years I have collected a mass of photographic reference material featuring many thatched cottages, old farm buildings and barns of every shape and size. With these I have put together this selection of paintings to help you master the art of painting various rustic buildings.

Finally, whatever the subject or style you choose, remember that painting should be fun, so enjoy it!

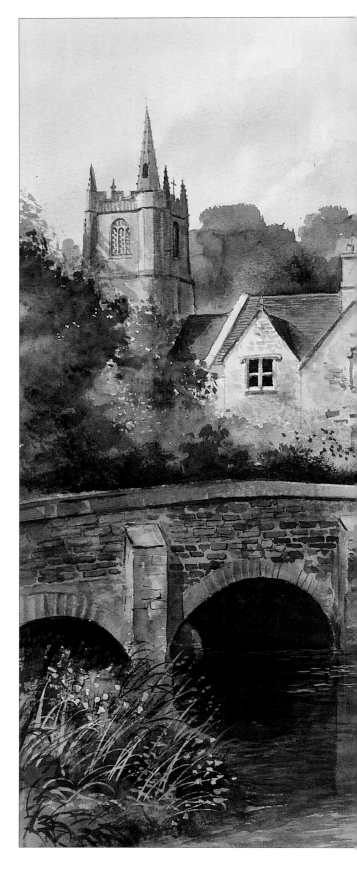

CASTLE COMBE
*75 x 56cm (29½ x 22in)*
*This village in the south Cotsolds is one of the most picturesque I know. Almost any view could inspire a painting.*

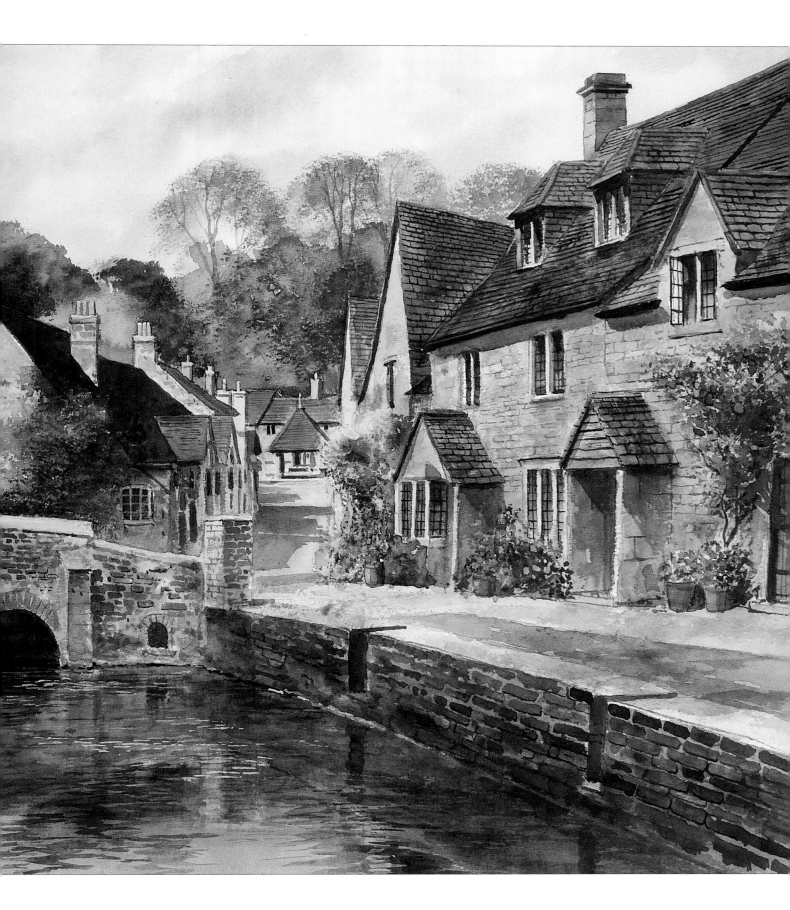

# Materials

## Paints

I always recommend buying the most expensive paints you can afford, as choosing cheaper ones turns out to be a false economy. Artist quality paints have a higher pigment content than student quality and for this reason you will find that you get better results with them, especially if you are painting large washes. If you try painting a large wash with student quality paints, you will find that you need to use more paint, so you may be wasting money you thought you had saved.

You can buy watercolour paints in either pans or tubes. I find that tube colours are more suitable for work in the studio, as I tend to paint on a larger scale there and use larger brushes that will not fit into pans. If you want to paint outside, however, you will find that a compact set of pans is more convenient and portable.

As well as my set of watercolour paints, I occasionally use white gouache.

*Watercolour paints in pans and tubes.*

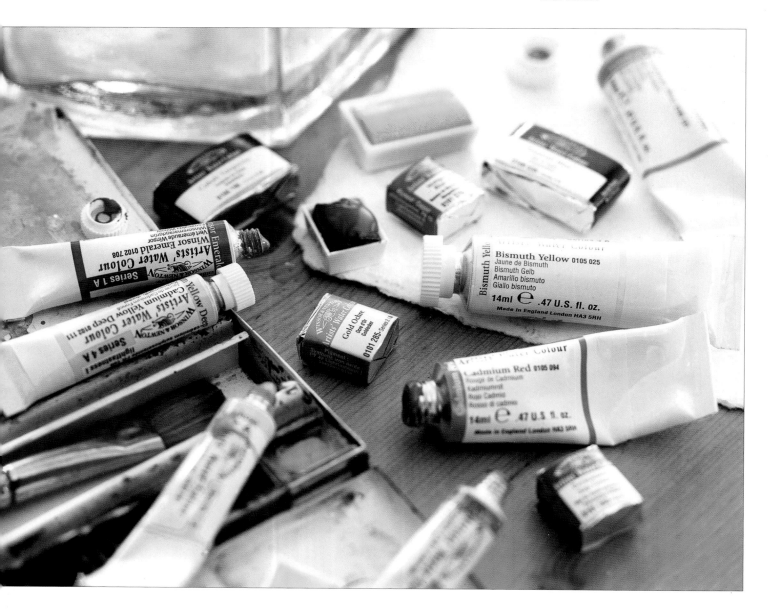

# My palette

I use a plastic palette with small wells for laying out paints and larger wells for mixing. I squeeze out colours from my tubes and lay them out in the order I prefer, with greens at one end, earth colours in the middle and blues at the other end. You should always mix colours in the larger wells of your palette before applying paint to the paper. This way you can try out the colour and consistency of the mix first before committing yourself on the painting itself.

    I use a basic palette of around twelve colours: French ultramarine, cobalt blue, permanent rose, cadmium red, cadmium yellow, raw sienna, green gold, olive green, Winsor green (blue shade), alizarin crimson, burnt sienna and burnt umber. I then add extra colours such as those used in the projects in this book: ultramarine violet, permanent mauve and quinacridone magenta for flower colours, Winsor orange for Spanish roof tiles, and yellow ochre, aureolin, indigo and Indian yellow for various other purposes.

*My well-used palette with my basic colours laid out in the order I prefer.*

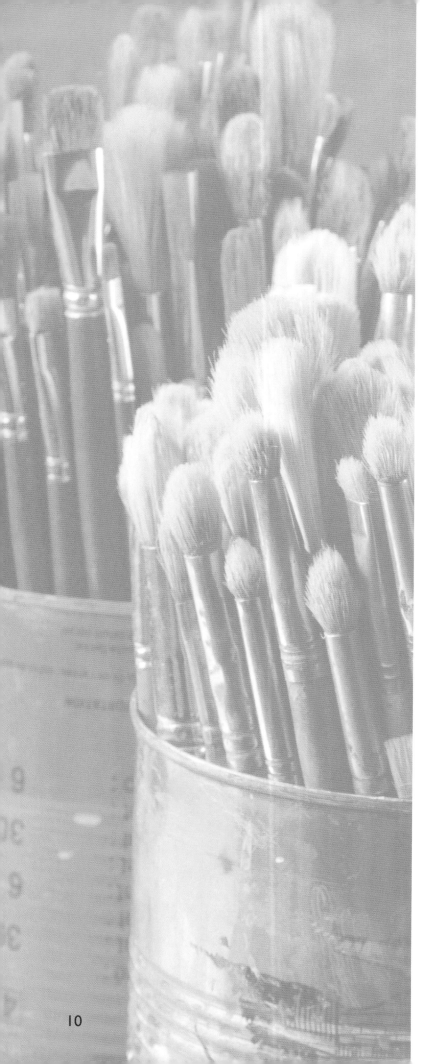

# Brushes

I am a great believer in using the right brush for the particular effect you are hoping to achieve in watercolour painting. You do not need to buy an enormous range; all the step-by-step demonstrations in this book were done with a selection from a range of seven brushes, as shown opposite.

A **large mop brush** is good for painting large washes, for instance for skies, as it holds a lot of paint.

A **no. 12 round** is also suitable for washes, as it holds a lot of paint, but it will also come to quite a fine point, so it is more versatile than a mop brush.

A **no. 8 round** is the brush you will probably use the most since it holds a fair amount of paint, but also comes to a good point so can be used for all but the finest details as well.

A **no. 4 round** brush is ideal for painting fine detail.

A **rigger** has long hair that comes to a very fine point, and was invented, as its name suggests, to paint the rigging on ships. It is good for painting very fine details of buildings, or grasses and flower stalks in landscapes.

A **fan brush** is good for flicking up grasses and for other textural effects.

A **flat brush** is useful for painting straight lines, and the one I used in this book has a **shaped, clear acrylic resin handle** that is useful for scraping out paint for textural effects such as painting reeds or grasses.

*Opposite*

*A large mop brush, a no. 12, no. 8
and no. 4 round, a rigger, a fan
brush and a flat brush with a shaped,
clear acrylic resin handle.*

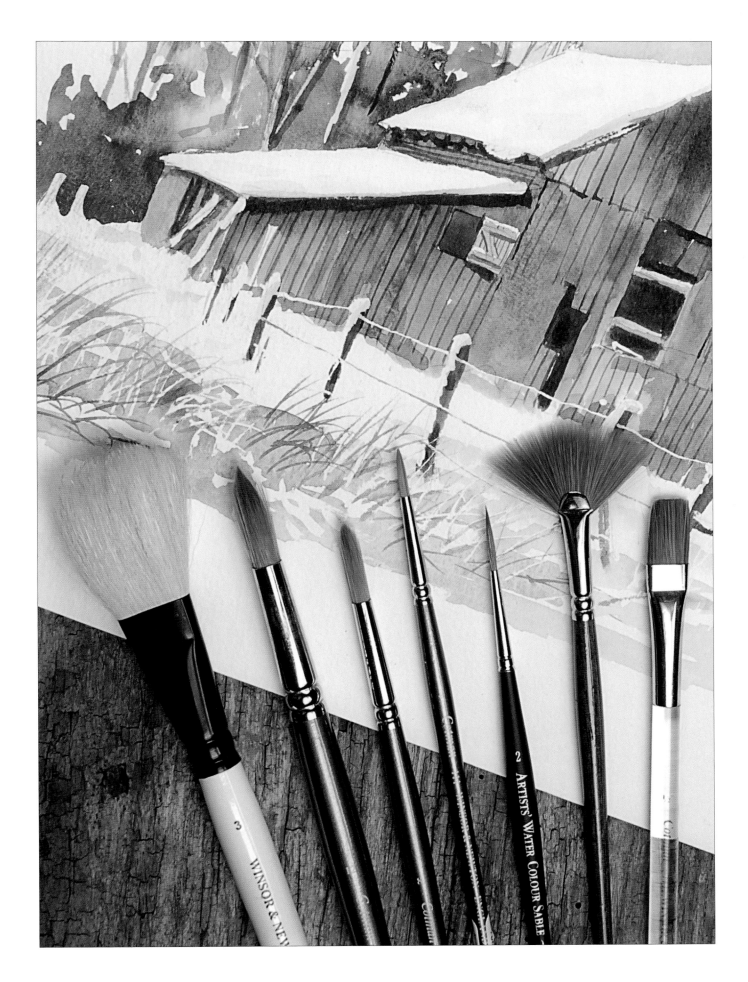

## Paper

Watercolour paper comes in three surfaces: Hot Pressed, which is smooth, Not, which has a bit more of a texture, and Rough. Hot Pressed paper is suitable for very detailed paintings such as botanical paintings and portraits. Rough paper is good for landscapes and seascapes, as the texture is very useful for creating effects, particularly with the dry brush technique. I have used Not paper for all the step-by-step demonstrations in this book. This allows you to capture a certain amount of detail, but also has enough texture for painting landscapes and buildings.

Paper also comes in different weights. I use a 300gsm (140lb) paper. Some cockling occurs when using this weight of paper. This is when the paper is unevenly wetted by watercolour washes and the paper fibres expand at different rates, causing the paper surface to wave and distort. Some artists stretch their paper by soaking it and taping it to a drawing board to dry. As the paper dries and shrinks, it is stretched and remains flat. However, I find that some cockling still occurs when washes are applied, so I do not bother with stretching paper. Instead, when the painting is finished and has dried, I place it face down and wet the back of it all over. When the water has soaked in and the paper has expanded, I place a drawing board on top of it and weigh it down with a pile of books. I leave it like this overnight and by the morning I find it completely flat.

# Other materials

**A hairdryer** can be used to speed up the drying process so that you do not end up overpainting on damp washes.

**Masking fluid** is applied to preserve the whiteness of the paper. It can be applied with a brush or a **ruling pen**. If you use a brush, you must protect it from the masking fluid, which dries to a rubbery consistency and can ruin your good brushes. Wet the brush and wipe it on an ordinary bar of **soap** to coat the hairs before dipping it in masking fluid. After applying the masking fluid, wash out the soap and the masking fluid comes out with it. A ruling pen is useful for masking fine detail and straight lines.

**Masking tape** is used to tape watercolour paper to the drawing board ready to begin painting.

I use a **bucket** to wash out my brushes when I am demonstrating painting, as you need plenty of water to keep brushes clean. You can use a couple of jars instead, one for washing the brushes and one for clean water to add to your colour mixes.

A 2B **pencil** is ideal for drawing out your scene, and you should keep it sharp with a sharpener. A hard **eraser** is useful for correcting mistakes.

I use an old **plastic card** for scraping out texture when painting rocks and other surfaces.

**Kitchen paper** is useful for wiping up spills, absorbing excess moisture from a wet paint brush, and for lifting out paint.

*Masking tape, masking fluid, a pencil, ruling pen, plastic card, soap, sharpener, hard eraser and kitchen paper.*

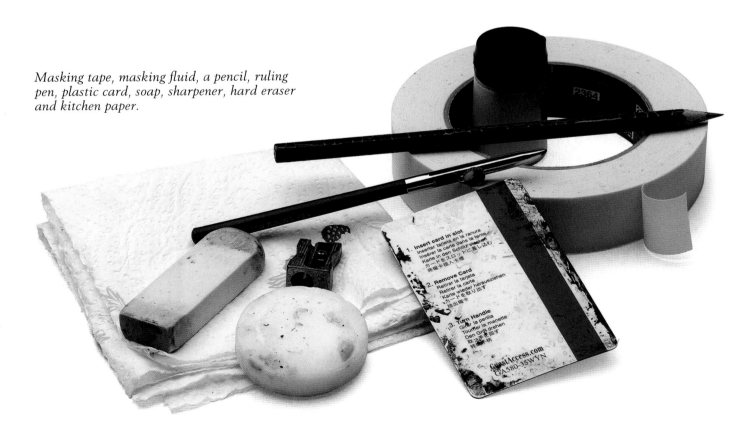

# Cottages

I love painting quaint cottages with picket fences and gardens bursting with flowers and colour. The variety of shapes and sizes is endless, with no two cottages looking the same. This means that no one can point at your painting and say, 'that's not right' – they are all individual. Every cottage has its own character and that is what makes them interesting to paint.

Painting cottages can present various challenges to the artist, so this section is full of tips and techniques to help you. You will learn how to paint various kinds of roof, doors, windows and walls, which should help you tackle virtually any cottage you come across. Cottage gardens are also a great favourite for painters, and there is a step-by-step demonstration here to show you how to approach them. Another step-by-step demonstration shows how to paint a thatched cottage, complete with advice on capturing the colours and texture of thatch. A selection of cottage paintings should inspire you to have a go, and show you how to achieve appealing composition, with garden paths leading into inviting scenes, and fences and garden walls created using various scraping out techniques.

THE VILLAGE GOSSIPS
*38 x 31cm (15 x 12¼in)*
*This cottage is almost swallowed up by its surroundings. The overhanging trees create darks at the back of the roof, and this emphasises the sunlight on the thatch. The rest of the cottage is hidden by a sumptuous, colourful display of flowers. Dappled sunlight on the picket fence helps to create a feeling of summer, and the girls gossiping in the lane tell another story.*

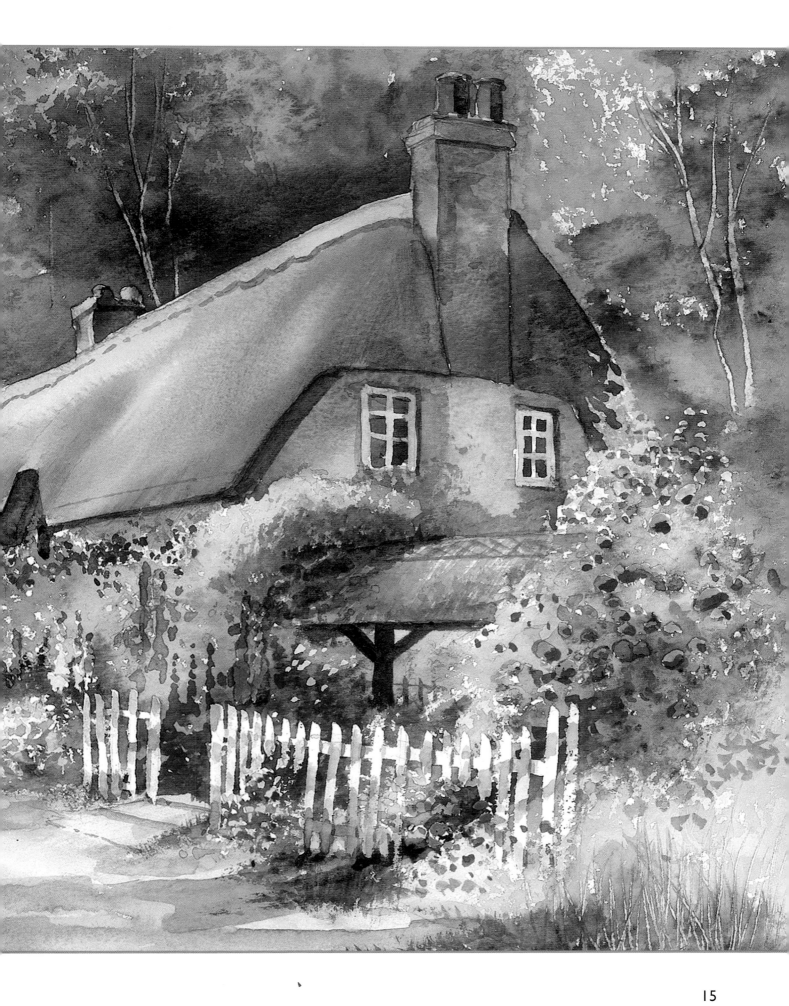

# Roofs

Shall we start at the top?

## Painting a thatched roof

Thatched roofs are rarely yellow. It is only when they are newly thatched that they are a yellow ochre straw colour, but within weeks of re-thatching, the colour changes to a soft, warm grey colour. I love the way that thatch just flops over the cottage like a soft, doughy hat.

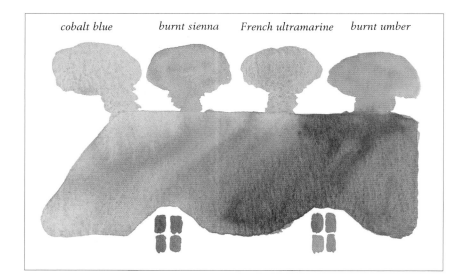

*cobalt blue*  *burnt sienna*  *French ultramarine*  *burnt umber*

*Colour mixes suitable for painting thatched roofs.*

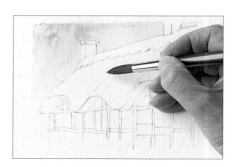

1 Wet the thatched roof with the no. 12 round brush.

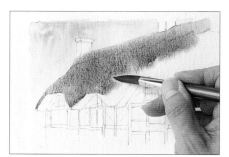

2 Drop in a grey mixed from ultramarine and burnt sienna.

3 While this is still wet, make a darker mix of the same colours with a little more ultramarine, and drop this in wet into wet to suggest shade.

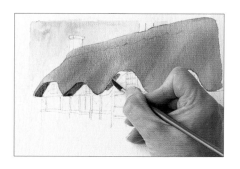

4 Paint the underside of the roof with the no. 8 round brush and a browner mix of burnt sienna and ultramarine.

5 Paint the ridge in the thatch with the same mix and the no. 4 round brush. Allow to dry.

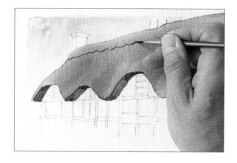

6 Take the 13mm (½in) flat brush and paint the texture of the thatch with the same mix and a very dry brush.

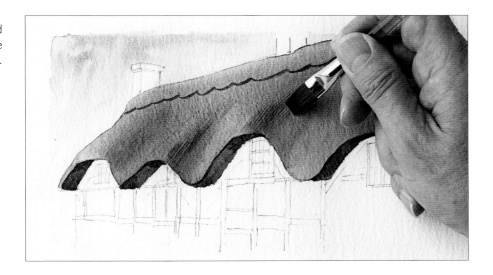

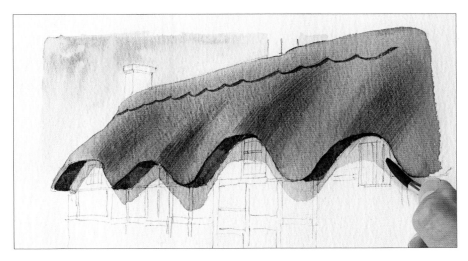

7 Mix cobalt blue with a touch of burnt sienna and paint the shadow under the eaves with the no. 8 brush.

*The finished thatched cottage.*

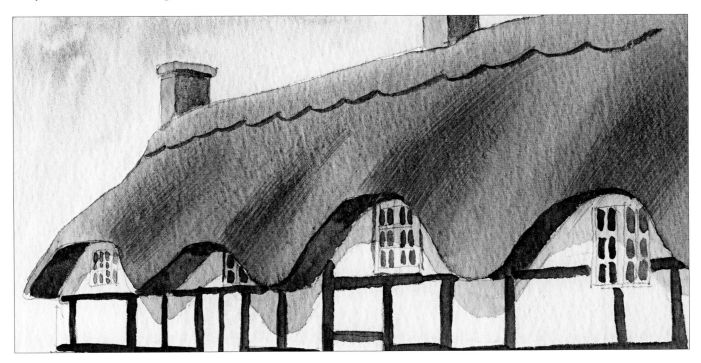

# Painting a slate roof

The colour for slates can be described as a blue/grey. You can use ultramarine and burnt umber but in this example I have used cobalt blue and burnt sienna. Remember to use more blue than brown to create slate grey.

1 Paint the ridge tiles at the top of the roof with the no. 8 brush and burnt sienna with a little ultramarine.

2 Mix a slate grey from cobalt blue and burnt sienna and paint the roof with the no. 12 brush.

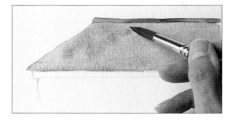

3 Drop in raw sienna wet into wet.

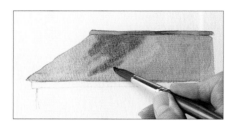

4 Drop in burnt umber and ultramarine wet into wet. Allow the roof to dry.

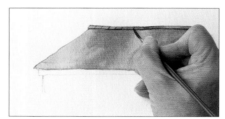

5 Use the rigger brush to add detail to the ridge tiles with the same mix, wet on dry.

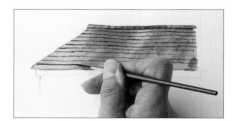

6 Paint in some of the horizontals with the same mix and a 'nervous line', made deliberately uneven.

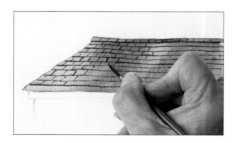

7 Paint the vertical joins between tiles in the same way.

*The finished slate roof.*

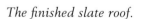

# Painting a pan-tiled roof

Pan-tiled roofs fall into that colour known as terracotta, which could be anything from a light, sandy red to a deep orange with a splash of blue. Try burnt sienna, raw sienna, burnt umber, cadmium red, ultramarine and cobalt blue, but not all at the same time.

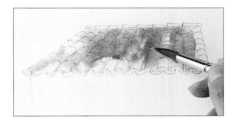

1 Wet the roof area with the no. 12 brush, then drop in Winsor orange followed by burnt sienna.

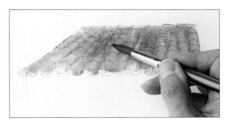

2 Drop in cobalt blue wet into wet to create the uneven, weathered effect of old pan tiles.

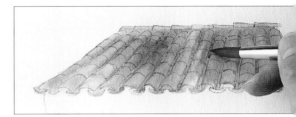

3 Still working wet into wet, run cobalt blue down the gulleys between the pan tiles.

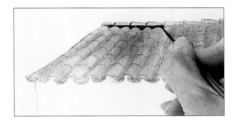

4 Paint the divisions between the ridge tiles and the shadow beneath them with the rigger brush and burnt umber with ultramarine.

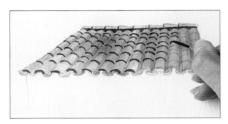

5 Use the same brush and mix to paint the pan tiles with little half-moon shapes. There is no short cut to painting these convincingly; you have to take your time.

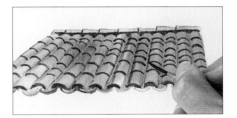

6 Paint the vertical shadows between tiles with a slightly darker mix of the same colours.

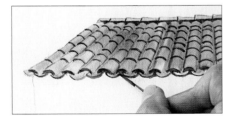

7 Paint the reversed tiles under the roof which carry away the water.

*The finished tiled roof.*

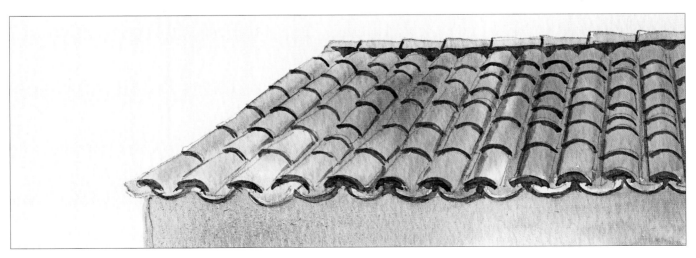

# Doors & windows

If you find the prospect of painting the whole of a house or building too daunting, why not start with a window or a doorway, or possibly the two together. These examples show that an attractive painting can be composed from just a section of a cottage, with the door or window suggesting a whole idyllic country scene just out of view. These close-up views allow you to capture the detail of brickwork, stone, thatch or wood, with flowers thrown in for a splash of colour.

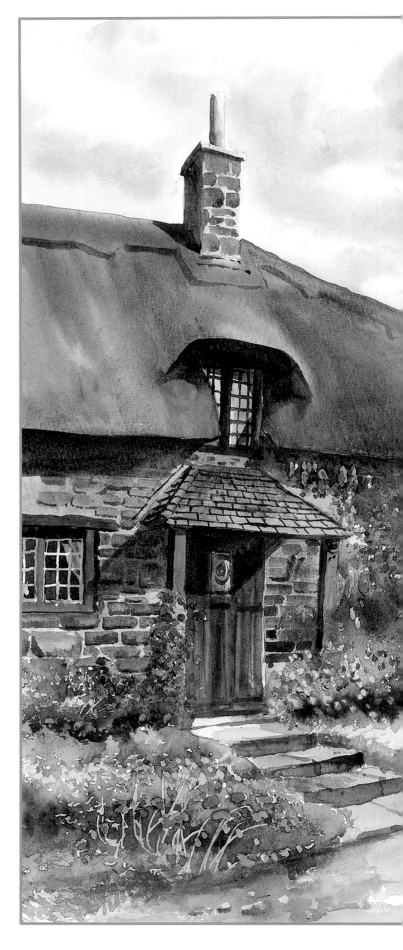

**COTTAGE PORCH**
*22 x 49cm (8¾ x 19¼in)*
*This tall painting has a strong central theme: all the main elements are lined up right down the centre of the painting. The roof and the tiled porch were painted wet into wet using ultramarine and burnt umber. Then some green was added before it had dried, to make the surface appear weathered.*

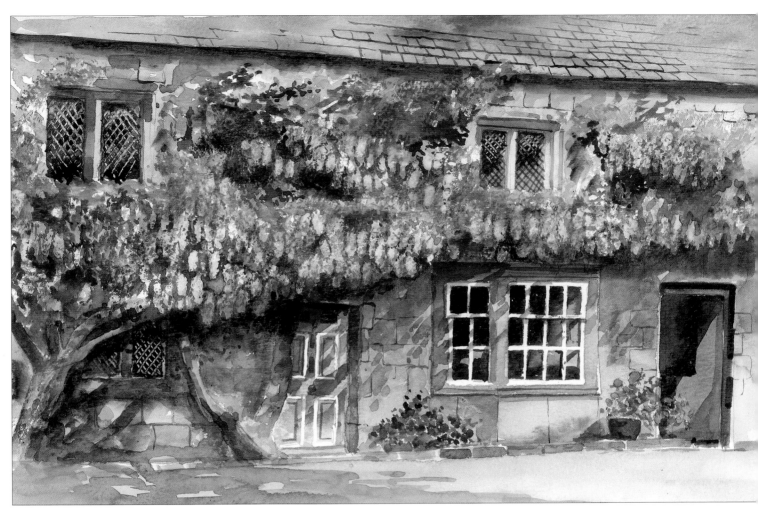

## BROADWAY COTTAGE
*42 x 28cm (16½ x 11in)*

*Spring sees the arrival of wisteria, which has that bluebell effect – everyone loves it. This magnificent vine spreads its way along the front of these old cottages in Broadway in the Cotswolds. Masking fluid was used for the blooms and the colours are cobalt blue and permanent rose.*

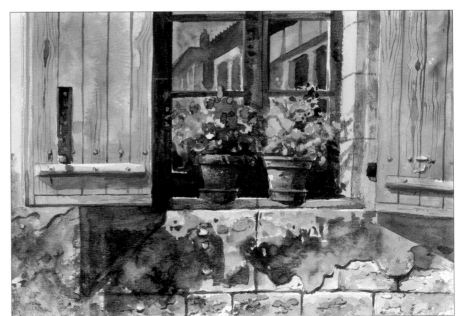

## SUNNY SILL
*29 x 21cm (11½ x 8¼in)*

*If the whole of the window is too much, why not tackle part of it? Add some interest by painting some reflections on the glass.*

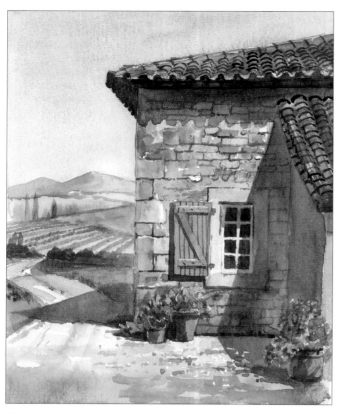

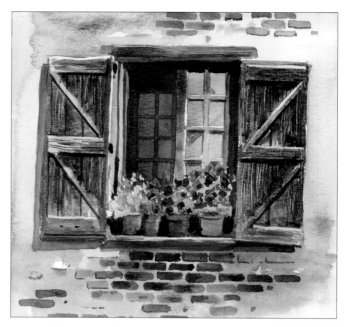

*Just adding some flowers to your painting can inject some much needed colour and interest.*

*Changing the colour of a door or shutters can make your subject more appealing.*

*This rustic shop-front has shelves of colours just shouting out 'paint me'.*

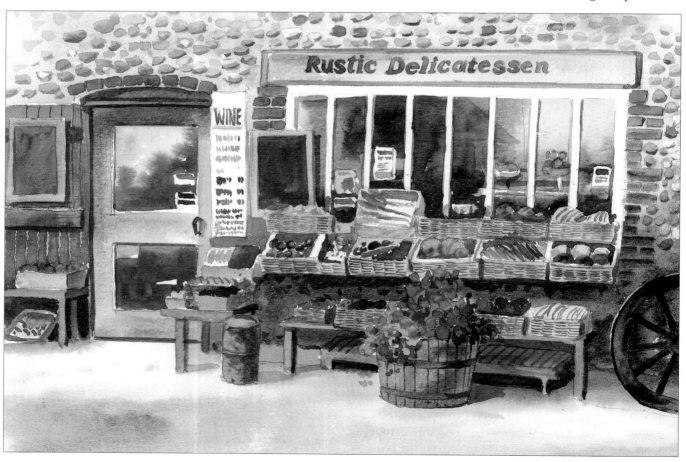

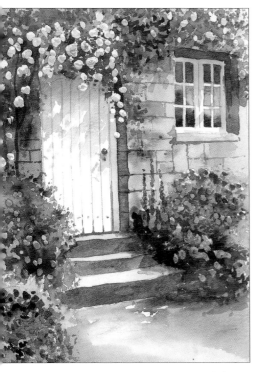

*The sunlit area in the centre of the painting above is highlighted by the shade on either side.*

*Plenty of warm colours are used to capture the summer sunshine, with cooler tones under the roses inviting you to take shade in the doorway.*

*This rustic wall combines a real mess of different types of stone and brickwork. Note the silhouette shape of a house reflected in the window.*

# A Spanish Doorway

What I love about this picture of a Spanish doorway is the simplicity and freshness of the subject. Painted on a plain white background, the cool blues of the shutter and door contrast with the warm terracotta colour of the porch and steps. Deep shadow under the porch suggests hot Mediterranean sunshine, and brightly coloured flowers finish off the scene.

### YOU WILL NEED

Not paper, 26 x 34cm (10¼ x 13⅜in)
Masking fluid and soap
Brushes: no. 8 round, rigger, no. 12 round
Colours: Winsor orange, burnt sienna, French ultramarine, cobalt blue, burnt umber, raw sienna, cadmium yellow, olive green, cadmium red, permanent rose

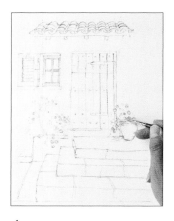

1 Apply masking fluid to the window frame and the flowers. Protect the brush by wetting it and wiping it in soap before you start.

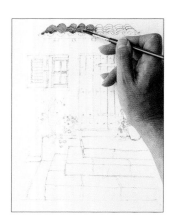

2 Paint the porch tiles with the no. 8 brush and Winsor orange. Drop in burnt sienna wet into wet.

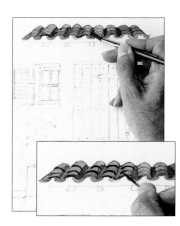

3 Add ultramarine to burnt sienna and paint the shadowed parts of the tiles wet into wet. Allow to dry and paint the tile edges wet on dry with the rigger brush.

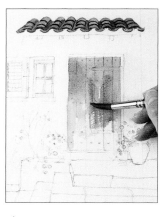

4 Use the no. 12 brush to paint the door and the shutter with cobalt blue.

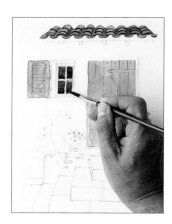

5 Use the no. 8 brush and ultramarine with burnt umber to paint the dark in the window.

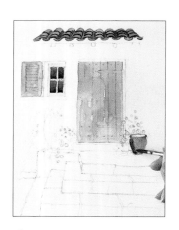

6 Paint the pot with a wash of burnt sienna, then drop in ultramarine wet into wet for the shaded part.

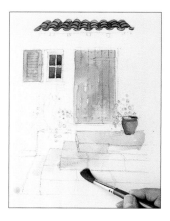

7 Wash over the steps with the no. 12 brush with a light wash of raw sienna with a touch of burnt sienna. Allow to dry.

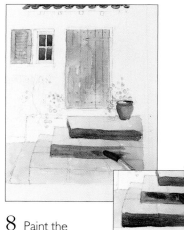

8 Paint the shaded parts wet on dry with burnt sienna and a touch of ultramarine. Then drop in ultramarine wet into wet.

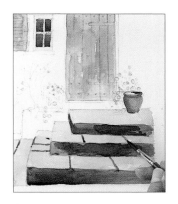

**9** Paint the cracks between the stones of the steps with the no. 8 brush and burnt sienna and ultramarine.

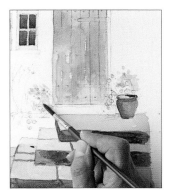

**10** Paint the greenery in the pots with cadmium yellow and olive green.

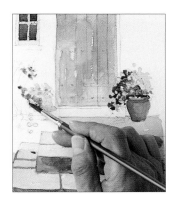

**11** Add ultramarine to the mix to make a darker green and drop this in wet into wet.

**12** Paint in the stems with the rigger brush and a mix of olive green and burnt umber.

**13** Paint the details on the door and shutter with the rigger and ultramarine and burnt umber.

**14** Change to the no. 8 brush and use the same mix to paint the dark area under the porch roof, and the wooden supports.

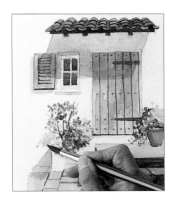

**15** Paint the shadow under the porch with the no. 12 brush and cobalt blue with burnt sienna. Add further shadows and allow to dry.

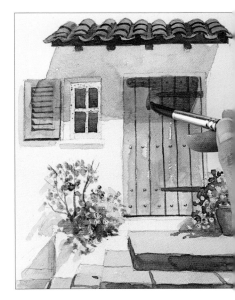

**16** With a stronger mix of the same colours, darken the shadow on the door.

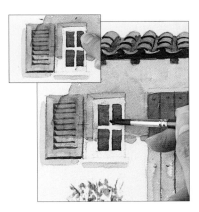

**17** Remove the masking fluid with a clean finger. Use the cobalt blue and burnt sienna mix to paint the shadow over the window frame.

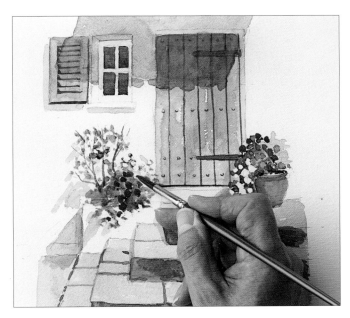

**18** Paint the flowers in the pots with cadmium red.

25

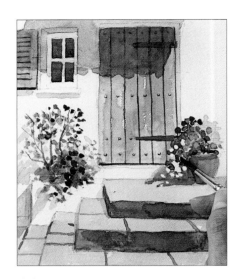

**19** Paint more flowers on the right with permanent rose.

**20** Add more flowers on the left with cadmium yellow.

**21** Deepen the shadows around the window and the door with cobalt blue and burnt sienna.

*The finished Spanish Doorway.*

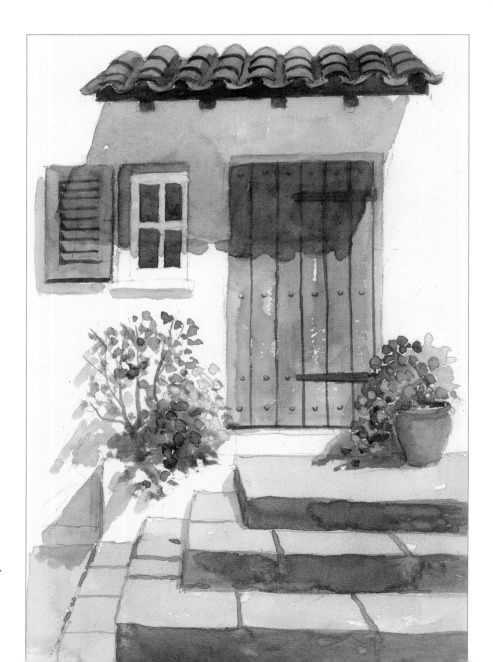

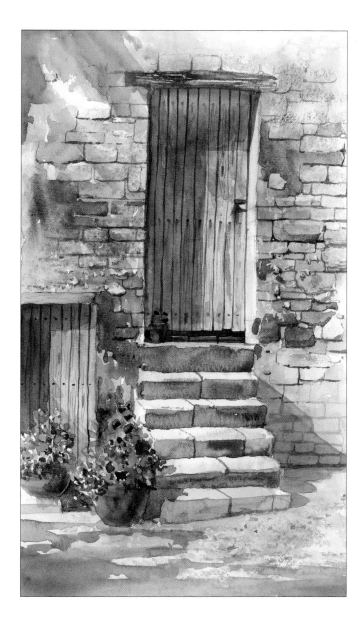

## THE FADED DOORWAY
*23 x 41cm (9 x 16¹/₈in)*

*This weathered rustic doorway is full of detail: fine woodgrain, crumbling stonework, even rust stains on the woodwork. The wall was painted wet into wet and then, when dry, the details were added with a rigger.*

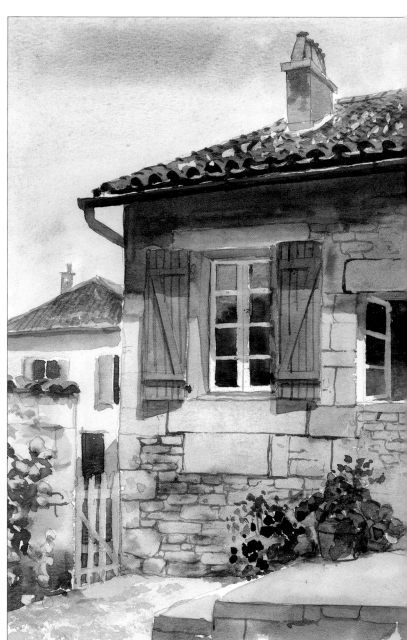

### BLUE SHUTTERS
*19.5 x 30cm (7¾ x 11¾in)*

*Masking fluid was used on the window frames and gate, and when this was removed, a wash of cobalt blue with burnt sienna was applied to put the woodwork in the shade.*

# Walls

Every building has its challenges when it comes to painting the walls, with such a variety of building materials used. Wooden walls look good with lots of detail – there are no short-cuts: start with the undercoat colour washed in wet into wet, then when that is dry, paint the woodwork detail on top using a fine brush. To achieve that rustic look, use what is known as a 'nervous line': this might come naturally to some artists, while others may have to work at it. It is achieved by allowing your hand to shudder slightly as you paint a straight line, thus creating an uneven brush stroke. We will call this 'rustic'.

**CHATTING ON THE PORCH**
*54 x 36cm (21¼ x 14¼in)*

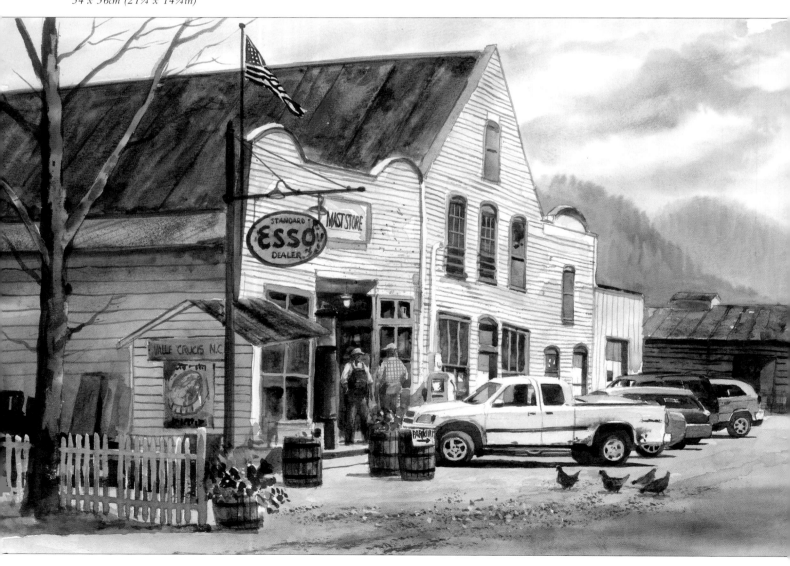

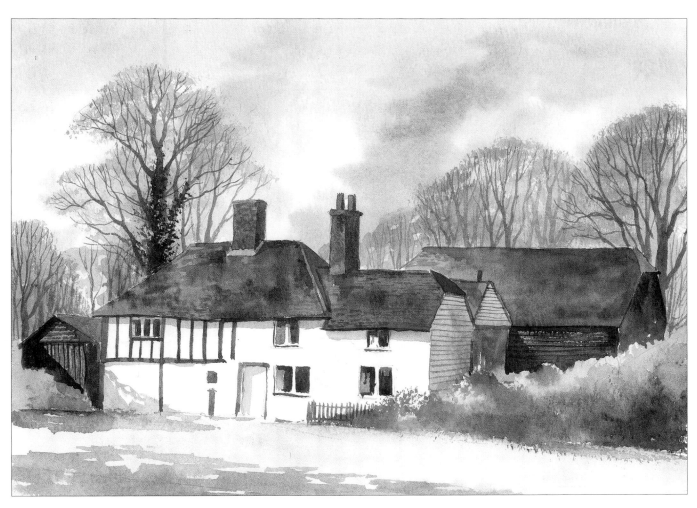

## KENTISH FARMHOUSE
*34 x 24cm (13³⁄₈ x 9½in)*

*Most period buildings were built using a timber frame and the gaps filled in with bricks or 'wattle and daub', leaving the framework exposed. This style of building is known as 'half-timbered'. The trend for painting the brickwork white and the wooden beams black only started in Victorian times. In certain parts of Britain the walls are coloured with attractive pastel shades, often unique to that area.*

STRATFORD
COTTAGE
*28 x 22cm (11 x 8¾in)*

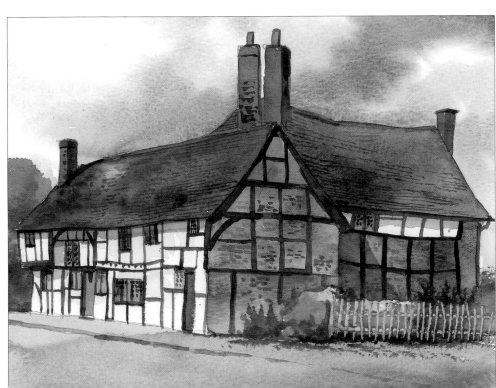

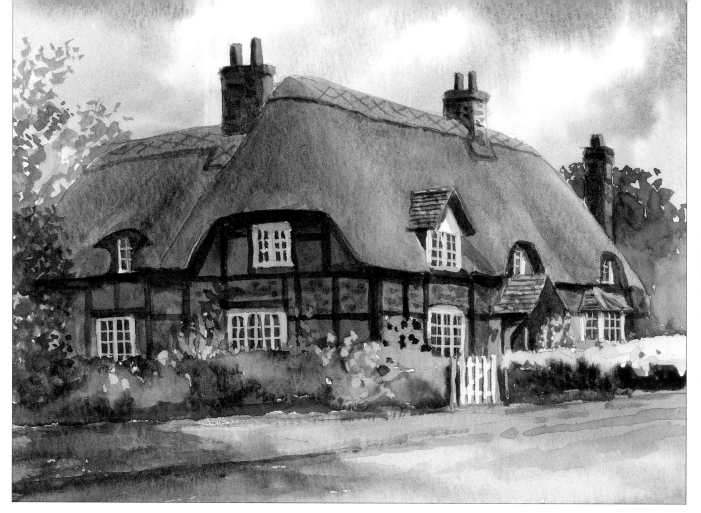

## RED-BRICK HALF-TIMBERED COTTAGE
*23 x 19cm (9 x 7½in)*

*This is a typical half-timbered brick cottage with a tiled dormer window and porch.*

## RED-BRICK COTTAGE
*23 x 22cm (9 x 8¾in)*

*In the 18th century, brick cottages with slate roofs were all the fashion, so to have a thatched roof was the cheaper option. The reason for this was that the cost of transporting slate was much higher than using local thatch. Ironically, nowadays the reverse is true.*

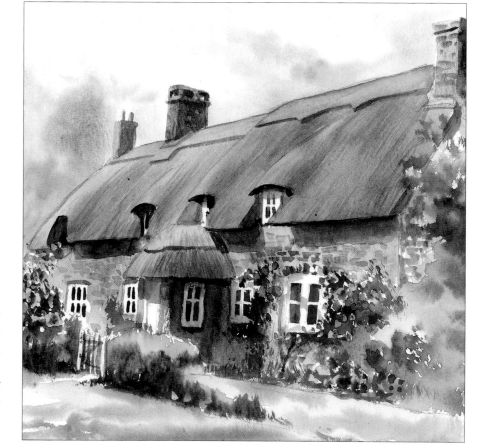

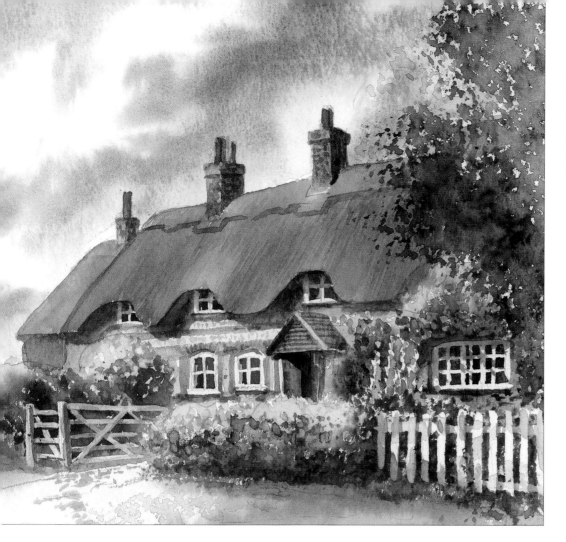

## FLINT AND BRICK COTTAGE

*22.5 x 20cm (8⁷/₈ x 7⁷/₈in)*

*This cottage was built using a mix of red brick and flint to create an attractive facade.*

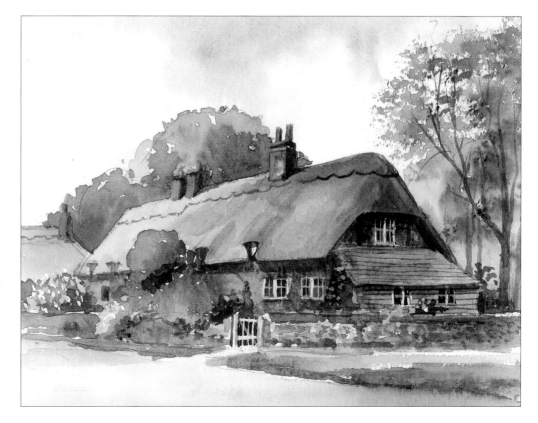

## JANE AUSTEN'S NEIGHBOUR

*20 x 17cm (7⁷/₈ x 6¾in)*

*The extension on this cottage has a slate roof and wooden walls, an odd combination which probably would not get planning permission these days. The cottage is in Chawton, Hampshire, opposite Jane Austen's house.*

# A Cottage Garden

The full impact of a country cottage garden comes at the height of summer, when the gardens are full of sumptuous colours. Roses round the door and hollyhocks taller than a person give you a good excuse to use masking fluid and all those odd bright colours you have collected in your paint box!

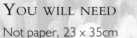
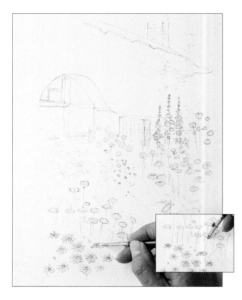

1 Draw the scene. Mask all the flower heads with masking fluid using a brush protected with soap. Use a ruling pen to apply masking fluid to the stalks.

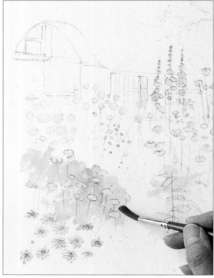

2 Use the no. 8 brush and a mix of cadmium yellow and a touch of olive green to begin painting the greenery in the foreground.

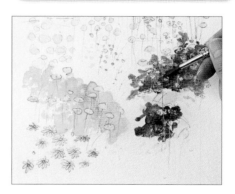

3 Add a stronger green mixed from Winsor green and burnt sienna.

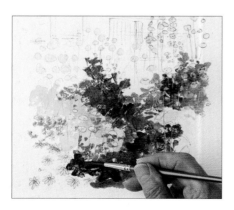

4 Paint the darker areas of foliage with a mix of ultramarine, Winsor green and burnt sienna.

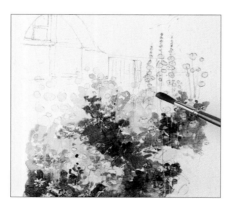

5 Continue painting with a lighter green mixed from olive green and cadmium yellow. The garden greenery should have patches of alternating dark and light.

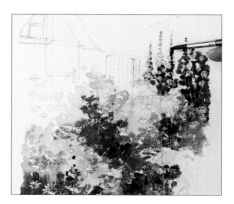

6 Paint the hollyhock foliage with Winsor green and burnt umber.

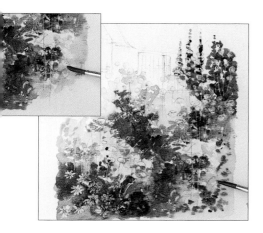
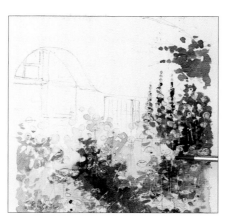
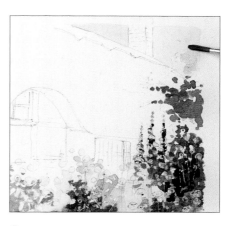

7  Paint the bottom right-hand corner with cadmium yellow and olive green. Drop in Winsor green and burnt umber wet into wet.

8  Deepen the darks in the area of the hollyhocks with a mix of ultramarine, Winsor green and a little permanent rose.

9  Paint the sky visible at the top of the painting with cobalt blue.

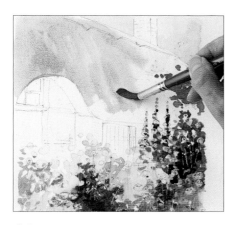
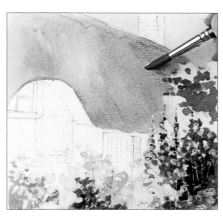
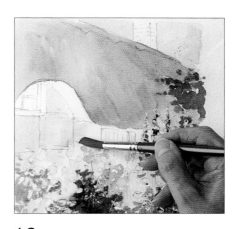

10  Wet the thatch area with the no. 12 brush. Paint it with cobalt blue and burnt sienna, then drop in raw sienna wet into wet.

11  Still working wet into wet, paint a bluer area on the right with a mix of cobalt blue and raw sienna. Allow to dry.

12  Paint the wall of the cottage with yellow ochre and a little cadmium red. Allow to dry.

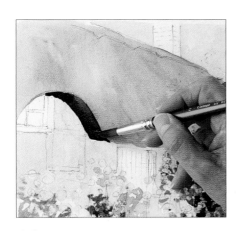
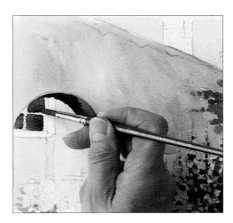
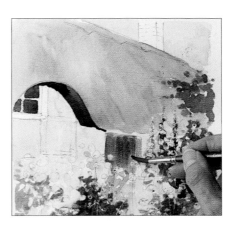

13  Paint the underside of the thatch with a dark mix of ultramarine and burnt umber.

14  Paint the window darks with the same mix and the no. 8 brush.

15  Paint the door with burnt umber.

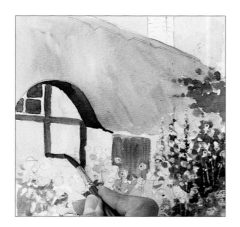

**16** Paint the timber frame of the cottage with burnt umber and ultramarine.

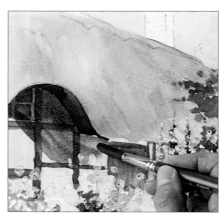

**17** Paint the shade under the thatched roof with a mix of cobalt blue, alizarin crimson and burnt sienna.

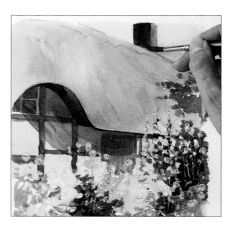

**18** Paint the chimney with burnt sienna and allow it to dry. Then paint the shaded part wet on dry with a mix of burnt sienna and ultramarine.

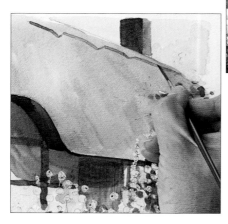

**19** Use the rigger brush and a mix of cobalt blue and burnt sienna to paint the ridge in the thatch.

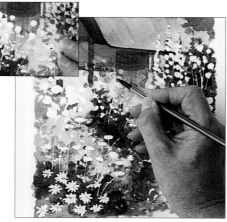

**20** Remove the masking fluid with clean fingers. Use the no. 8 brush to paint the large purple blooms with ultramarine violet.

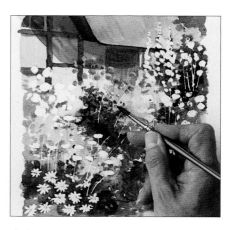

**21** Paint more flowers with a light wash of permanent rose.

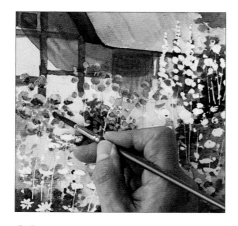

**22** Paint the flowers on the left with a light wash of permanent mauve, then drop in a darker wash of the same colour wet into wet.

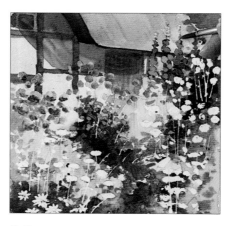

**23** Paint the hollyhock flowers with quinacridone magenta, then paint the unopened buds with olive green and cadmium yellow.

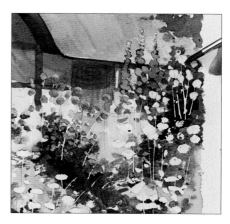

**24** Use cadmium yellow to paint the flowers to the right of the hollyhocks.

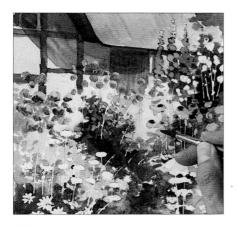

**25** Paint the orange flowers with cadmium yellow and Winsor orange, and drop in burnt umber for the centres, wet into wet.

**26** Paint the poppies with a light wash of cadmium red, then drop in a deeper wash of the same colour wet into wet.

**27** Paint the centres of the daisies with cadmium yellow.

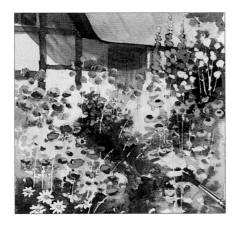

**28** Paint the flowers at the bottom right with cadmium yellow.

**29** Mix a light green from cadmium yellow and olive green to paint the stalks.

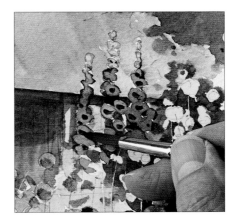

**30** Paint the centres of the hollyhock flowers with a strong wash of quinacridone magenta, wet on dry.

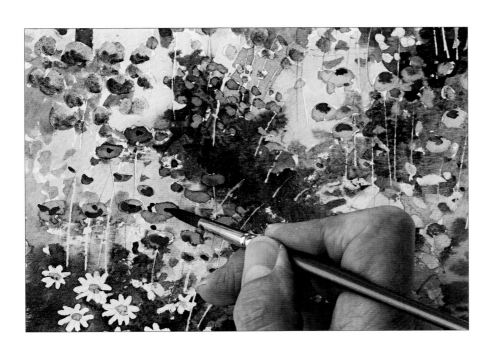

**31** Paint the centres of the poppies with a dark mix of ultramarine and burnt umber.

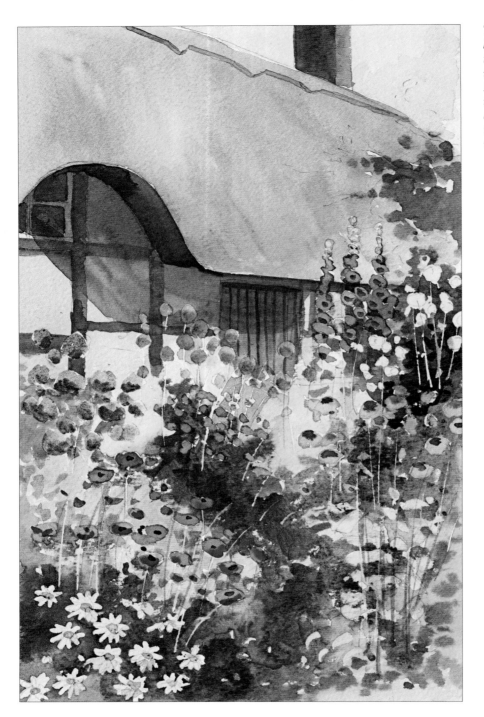

*The finished painting. At the last minute I added detail to the door with the rigger and ultramarine and burnt umber. I also shadowed the daisies with cobalt blue and painted darker stalks and grasses in the foreground with olive green, ultramarine and burnt umber.*

*Opposite*
### THE GARDEN GATE
*20 x 29cm (7⁷/₈ x 11³/₈in)*

*Masking fluid was used to good effect on the gate, flowers and window frame. After it was removed I dropped some dappled shade on to the fence and window frame using cobalt blue and a touch of burnt sienna.*

### SUNLIT PATH
*21 x 16cm (8¼ x 6¼in)*

*The misty light background entices the viewer to pass through the gate and beyond. This is achieved by creating a dark area around the light source, leading the viewer through the gate and into the light.*

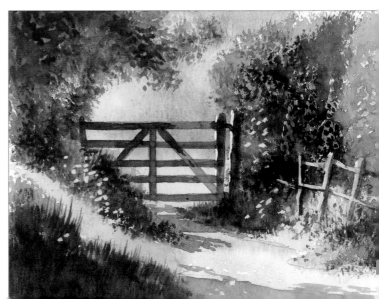

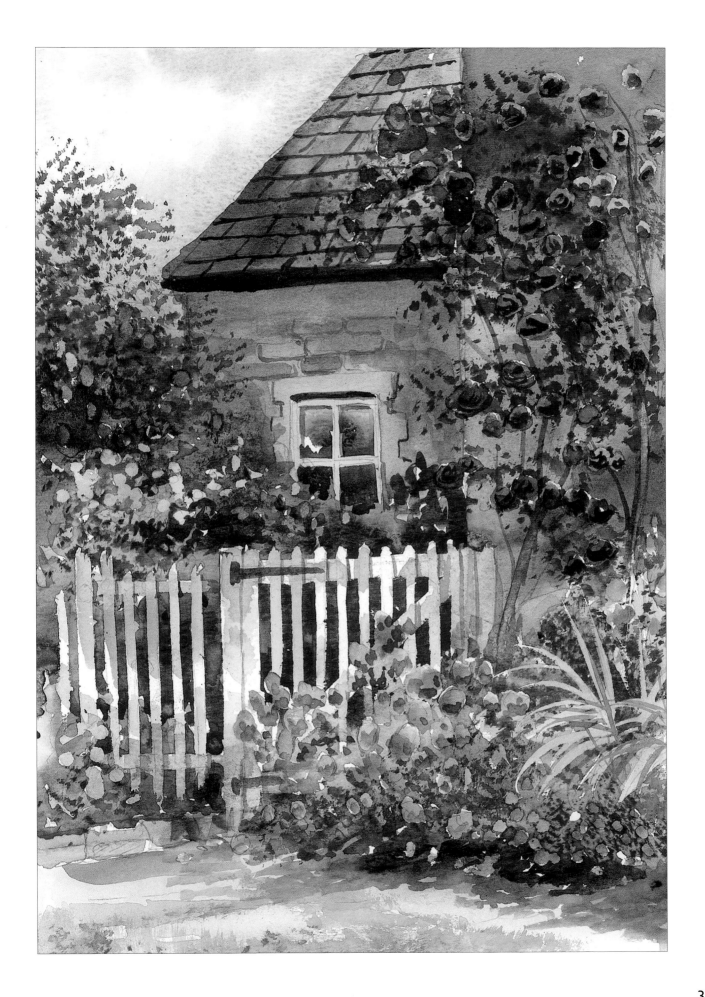

# Thatched Cottage

This half-timbered, black and white thatched cottage has all the picturesque ingredients you would expect to see in such an idyllic subject: little dormer windows set in the roof, a tiled porch, a stone garden wall and a white picket fence and a garden full of summer flowers including roses and hollyhocks. What more could you want?

## YOU WILL NEED

Not paper, 45 x 31cm (17¾ x 12¼in)

Masking fluid

Colours: French ultramarine, burnt umber, raw sienna, burnt sienna, olive green, cadmium yellow, Winsor green (blue shade), cobalt blue, cadmium red, permanent rose, Winsor orange, quinacridone magenta

Brushes: No. 12 round, no. 4 round, no. 8 round, rigger, 13mm (½in) flat brush

1  Draw the scene. Use masking fluid to mask the fence, flower heads and window frames.

2  Use the no. 12 brush to wet the sky area with clean water. Drop in ultramarine, painting round the cloud shapes.

3  Mix a grey from ultramarine and burnt umber and drop this in wet into wet. Allow to dry.

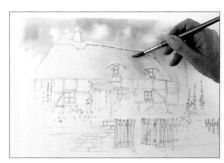

4  Wet the thatched roof area with clean water and drop in raw sienna first.

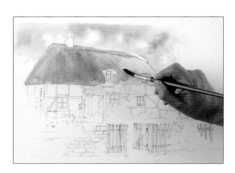

5  Brush on ultramarine and burnt sienna in the direction of the thatch, still working wet into wet.

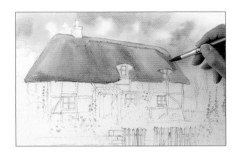

6 Use a darker mix to add shade to the raised parts over the windows, and beneath the lower edge of the thatch. Allow to dry.

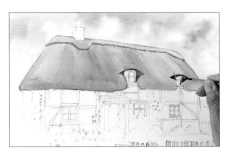

7 Use the no. 4 brush to paint the ridge in the thatch with the same ultramarine and burnt sienna mix. Paint the shadows around the windows in the same way.

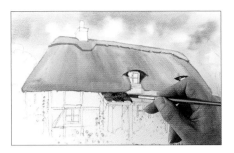

8 Paint the red tiles of the porch with burnt sienna and the no. 8 brush, then drop in cobalt blue wet into wet.

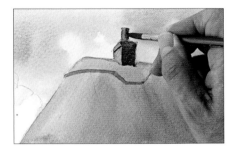

9 Paint burnt sienna on the chimney, let it dry and then darken the shadowed front and right-hand side with burnt sienna and cobalt blue.

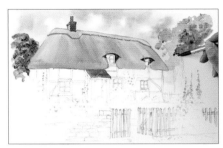

10 Mix ultramarine and olive green to paint the tree on the left with the no. 12 brush, then paint the right-hand tree with cadmium yellow and olive green. Drop in the darker green wet into wet.

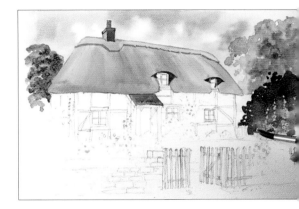

11 Mix Winsor green with burnt sienna and a touch of cadmium yellow, and paint over the masked hollyhocks. Drop in cadmium yellow at the bottom.

12 Add more cadmium yellow to the Winsor green mix and paint the foliage on the left of the cottage.

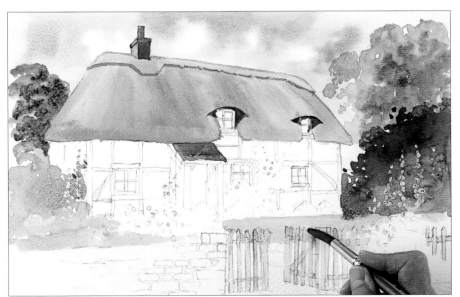

13 Add more cadmium yellow to the mix and paint the lawn. Allow to dry.

**14** Use the no. 12 brush to paint dark foliage with a mix of Winsor green and burnt sienna at the side of the porch and up the wall on the right.

**15** Add more cadmium yellow to the mix and paint the lighter parts of the foliage wet into wet.

**16** Paint the lightest parts with cadmium yellow and just a hint of the dark green.

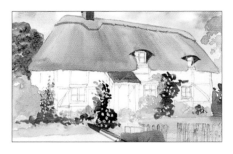

**17** Mix cadmium yellow and cadmium red and touch it in among the greens.

**18** Paint the hollyhocks with cadmium yellow and a touch of olive green, then drop in burnt sienna and Winsor green.

**19** Paint the dark green over the fence area so that it will provide a contrast when the masking fluid is removed.

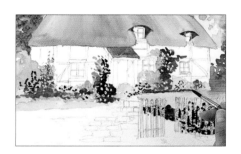

**20** Take the no. 8 brush and add depth and texture to the flower garden with Winsor green and burnt sienna. Paint a line to divide the flower bed from the lawn.

**21** Use the no. 12 brush to paint a pale wash of raw sienna and burnt sienna over the wall.

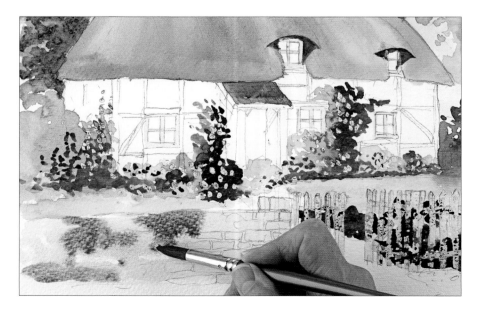

**22** Drop in burnt umber wet into wet and let it spread into the background.

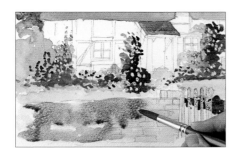

**23** Drop in cobalt blue wet into wet. Allow to dry.

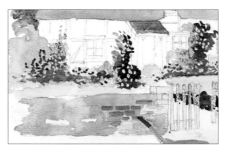

**24** Use the no. 8 brush and a mix of burnt sienna and cobalt blue to paint in some bricks in the wall. Allow to dry.

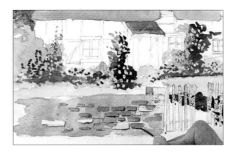

**25** Paint between the bricks with the rigger and a darker mix of the same colours, wet on dry.

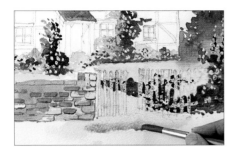

**26** Use the no. 12 brush to paint raw sienna over the footpath, then drop in a touch of burnt sienna.

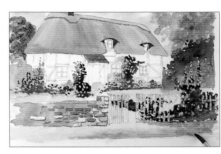

**27** While the footpath is still wet, drop in cobalt blue in the foreground to break it up and create the impression of shade.

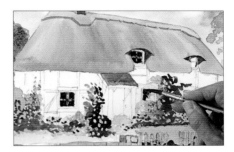

**28** Mix burnt umber with ultramarine and use the no. 8 brush to paint the window darks over the masking fluid.

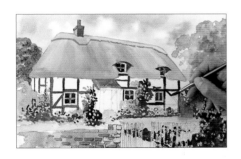

**29** Paint the cottage's woodwork with burnt umber and ultramarine. Do not worry about making the lines dead straight as they are meant to be old and uneven.

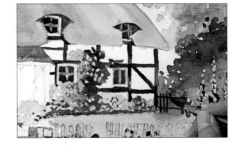

**30** Paint the little fence on the right of the cottage with the same mix.

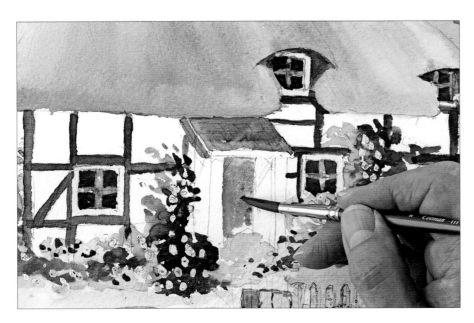

**31** Mix cadmium red with a little burnt sienna to paint the front door.

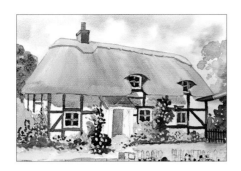

**32** Use the no. 12 brush and a mix of cobalt blue with a touch of burnt sienna to paint the shadow under the thatch.

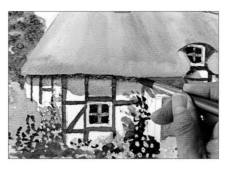

**33** While the paint is still wet, run a stronger mix of the same colours along just under the roof line and let it bleed down and soften into the first wash.

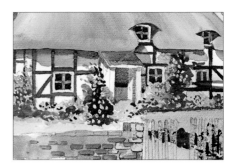

**34** Paint shadow over the doorway and beside the shrubs with the same mix.

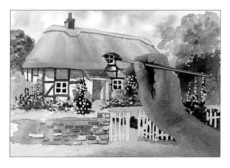

**35** Rub off the masking fluid, then use the no. 8 brush and cobalt blue with burnt sienna to paint shade over the window frames in the roof area.

**36** Shade the right-hand sides of the fenceposts with the rigger brush and the same mix.

**37** Still using the rigger brush, paint the details of the tiled porch with ultramarine and burnt umber.

**38** Darken the door with the no. 8 brush and burnt umber.

**39** Paint some of the flowers with cadmium red.

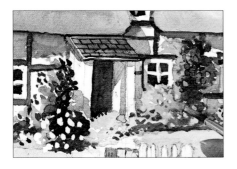

40 Paint some more flowers in cadmium yellow.

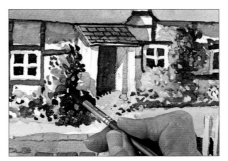

41 Continue painting the cottage garden, adding flowers in permanent rose.

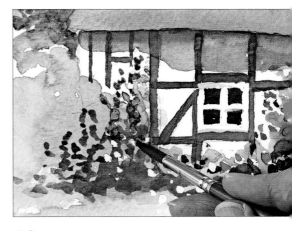

42 Add cobalt blue to permanent rose to paint the purple flowers on the left.

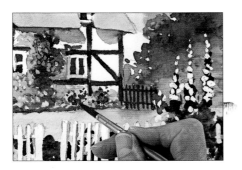

43 Use Winsor orange to paint more flowers.

44 Paint the hollyhocks on the right with quinacridone magenta.

45 Paint the flowers in front of the fence with cadmium red.

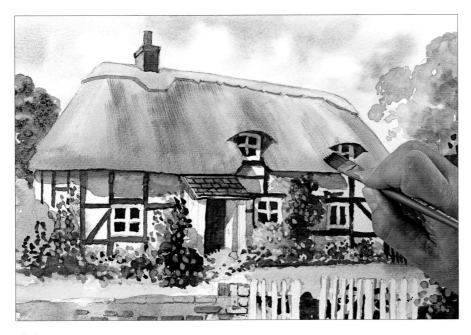

46 Take a 13mm (½in) flat brush and separate the ends and use it very dry with a mix of cobalt blue and burnt sienna to stroke in the detail of the thatch.

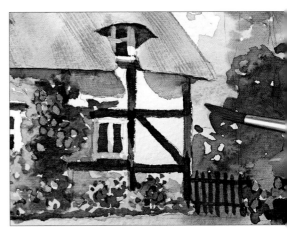

47 At this last stage I filled in a light gap on the right of the cottage with cadmium yellow and olive green.

*The finished painting. After standing back to have a look at the painting, I added tree trunks with burnt umber and olive green and the rigger brush.*

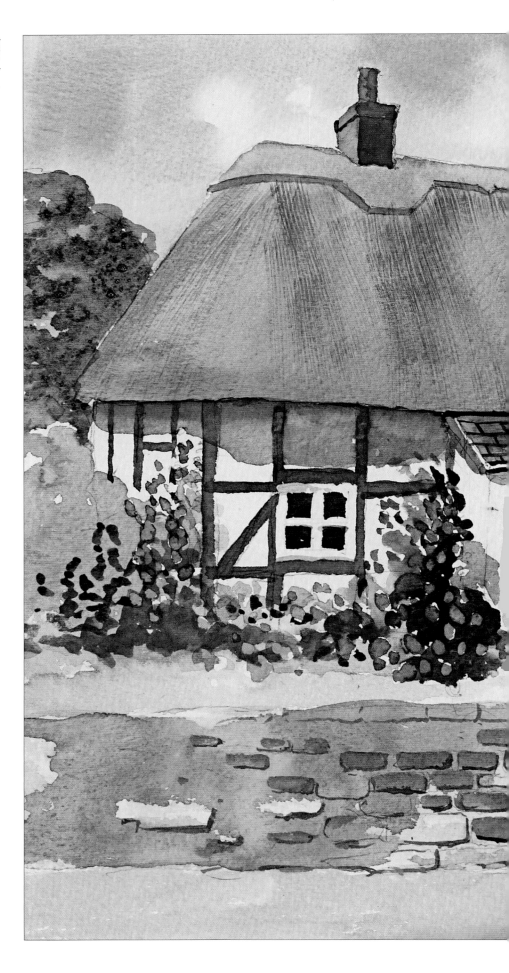

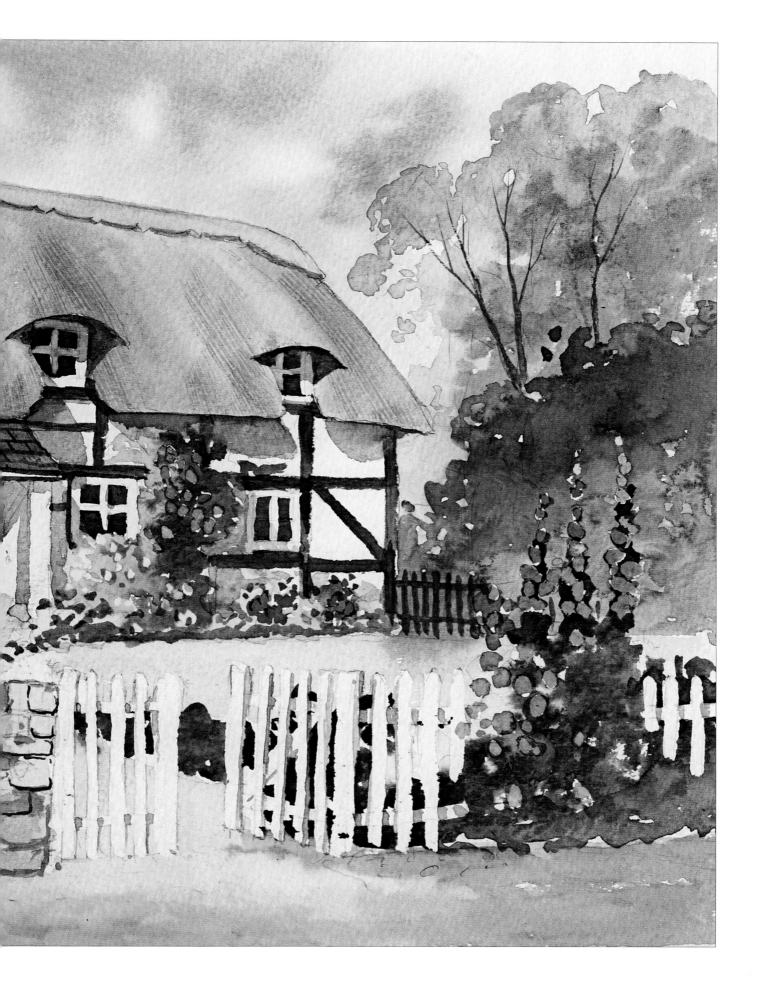

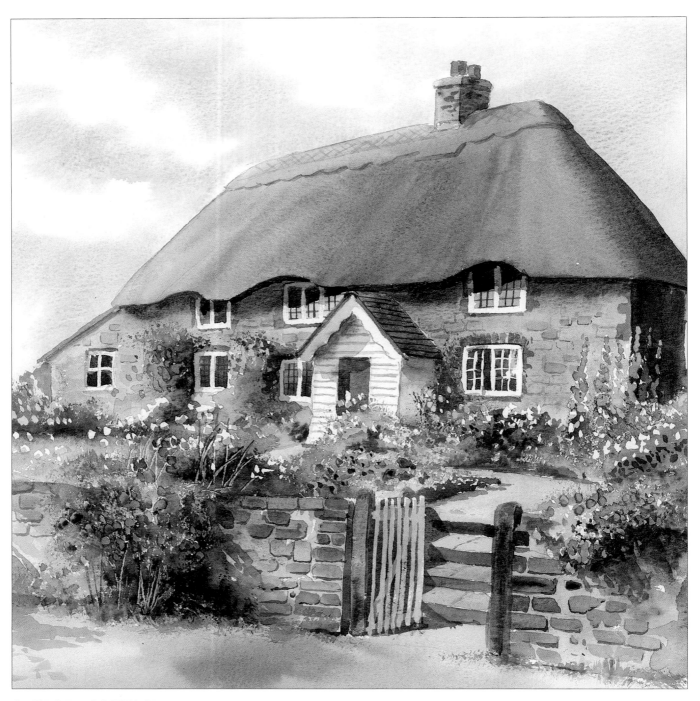

## AMBERLY COTTAGE
*33 x 33cm (13 x 13in)*

*The garden gate left slightly ajar invites the viewer to enter this enchanting garden. This is not the first time I have been led up the garden path!*

*Opposite*

## DARTMOOR HIDEAWAY
*29 x 41cm (11³/₈ x 16¹/₈in)*

*The striking feature of this painting is the stone wall and gate, partly in shade. This adds strong tonal contrasts, making the cottage appear to be bathed in sunlight. The warm autumn colours invite the viewer to go through the gate and into the garden.*

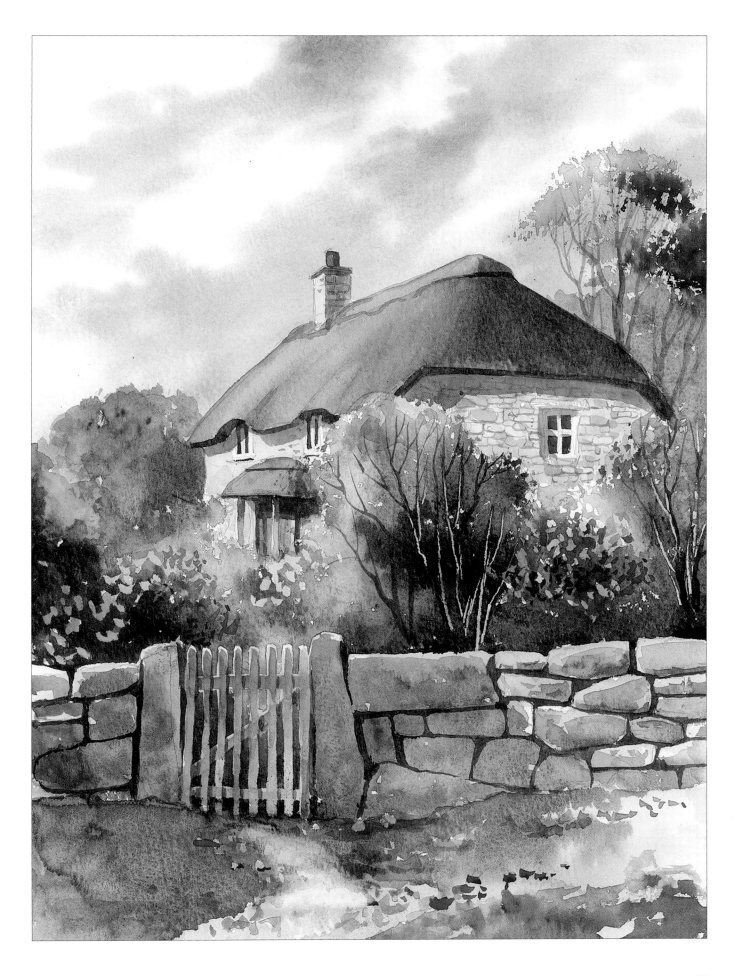

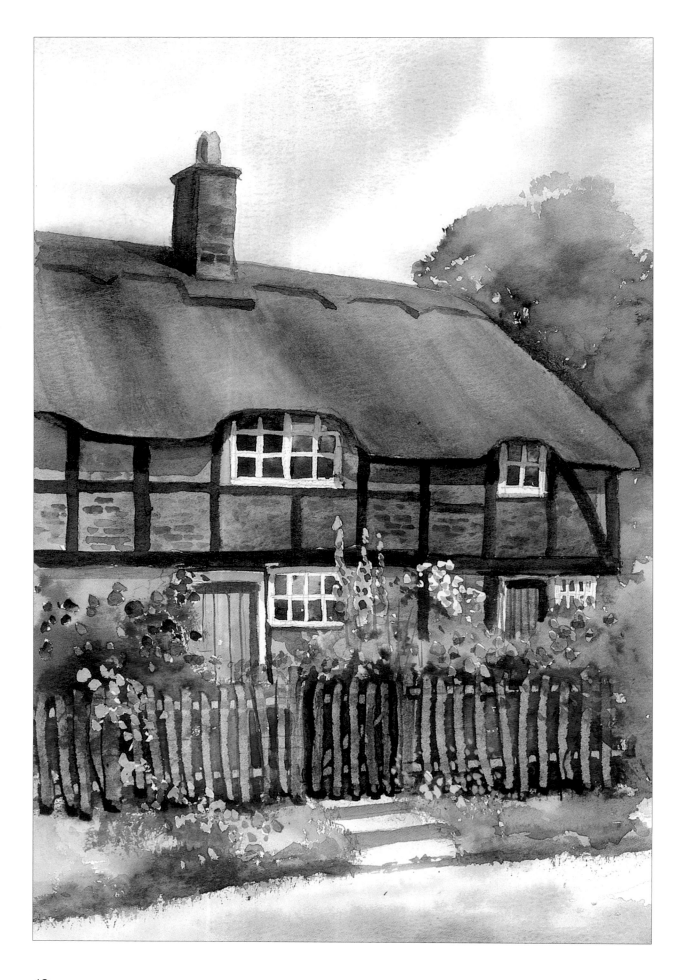

*Opposite*
## RUSTIC FENCE
*22 x 37cm (8⅝ x 14½in)*

*I have used the shaped end of an acrylic resin-handled brush to scrape out the fence posts, creating the soft green colour. This can be achieved only if the background colour is still wet.*

## OVER THE GARDEN WALL
*31 x 27cm (12¼ x 10⅝in)*

*The stone wall in front of this charming thatched cottage was created by scraping out the stonework using the shaped end of an acrylic resin brush. Adding a pair of simple figures completes this idyllic scene.*

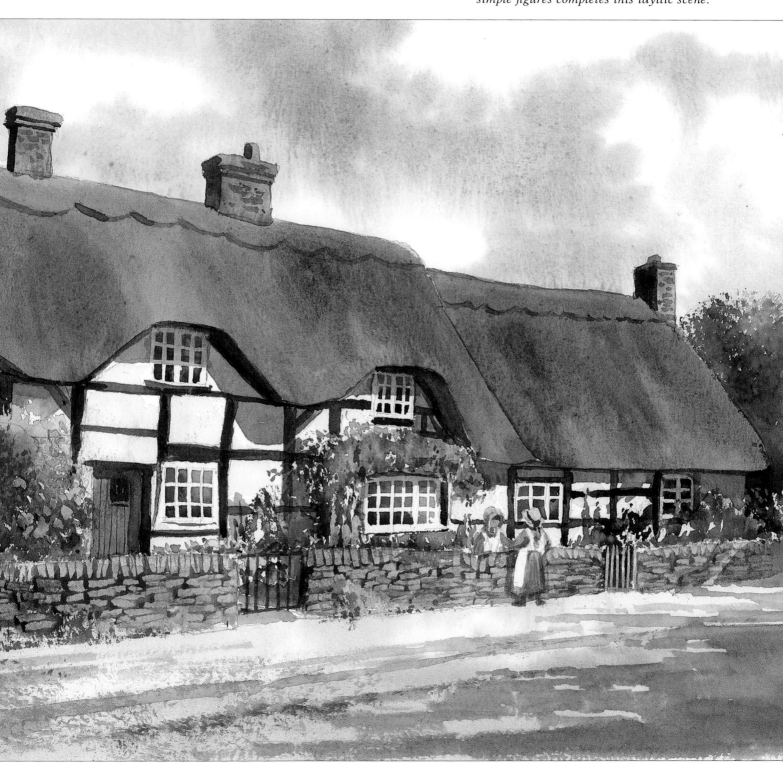

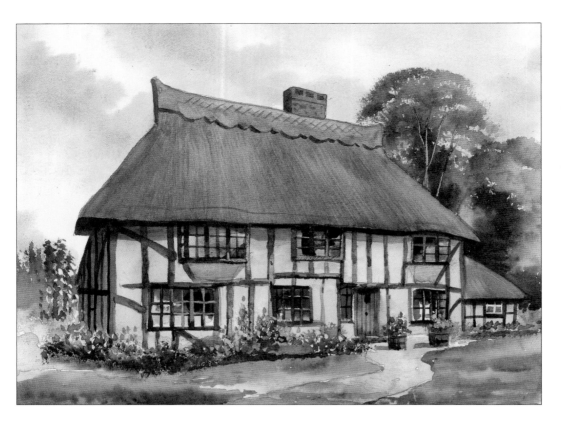

## COLOUR-WASHED COTTAGE
*31 x 24cm (12¼ x 9½in)*

*This quaint cottage in Essex is called 'the Pink' – I suppose it was once called 'the Pink House' or 'the Pink Cottage' but at some point, half the sign dropped off and it now has a shortened name. I have used permanent rose and raw sienna to create the pink.*

## THE THATCHED INN
*36 x 26cm (14¼ x 10¼in)*

*Colour-washed cottages have an attractive appeal with their pinks, creams, ochres and blues. Certain regions in Britain have specific colours associated with them. This inn is tucked away in a quiet corner of Devon.*

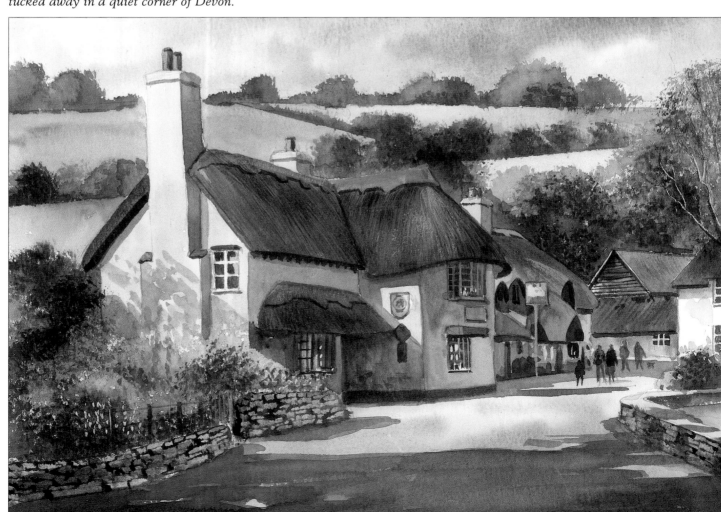

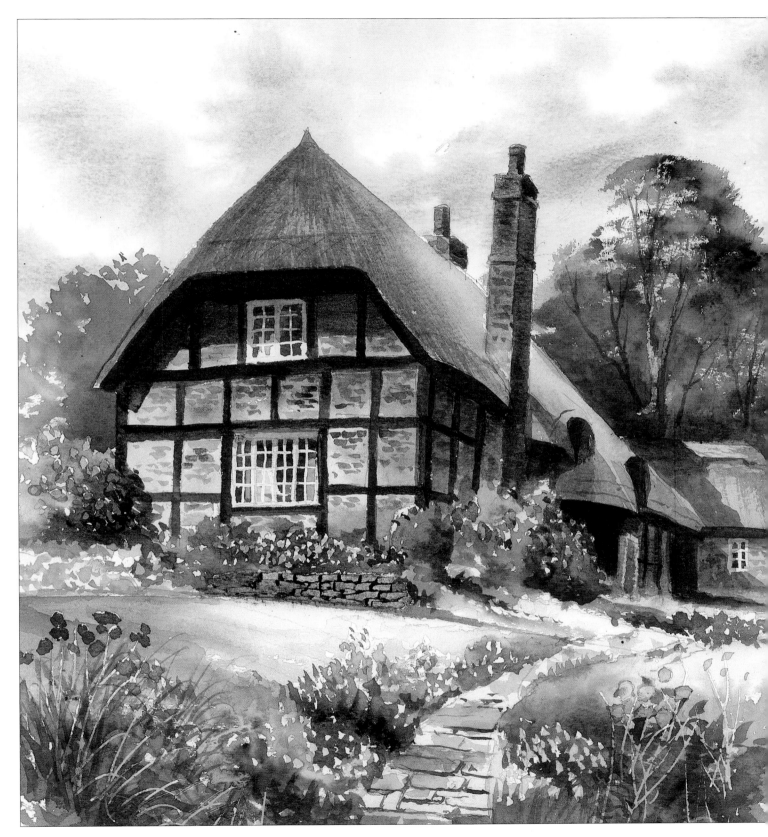

## THE GARDEN PATH
*30 x 33cm (11¾ x 13in)*

*I painted the walls of the cottage first, wet into wet; then when they were dry, I applied the timber frame over the background colour and added details of the brickwork on top using short, horizontal brush strokes.*

# MILLS

Whether it is an old mill by a stream or a windmill on a windswept hill, mills provide a constant supply of painting subjects. Mills of this type are a symbol of the past; they are no longer being built so they will become more and more rustic with time and decay.

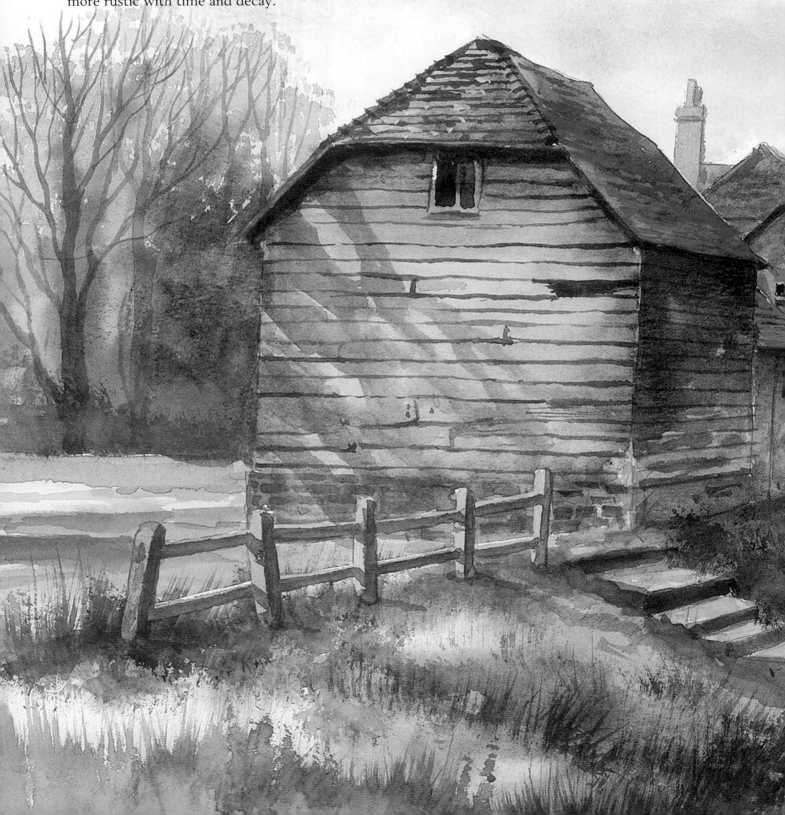

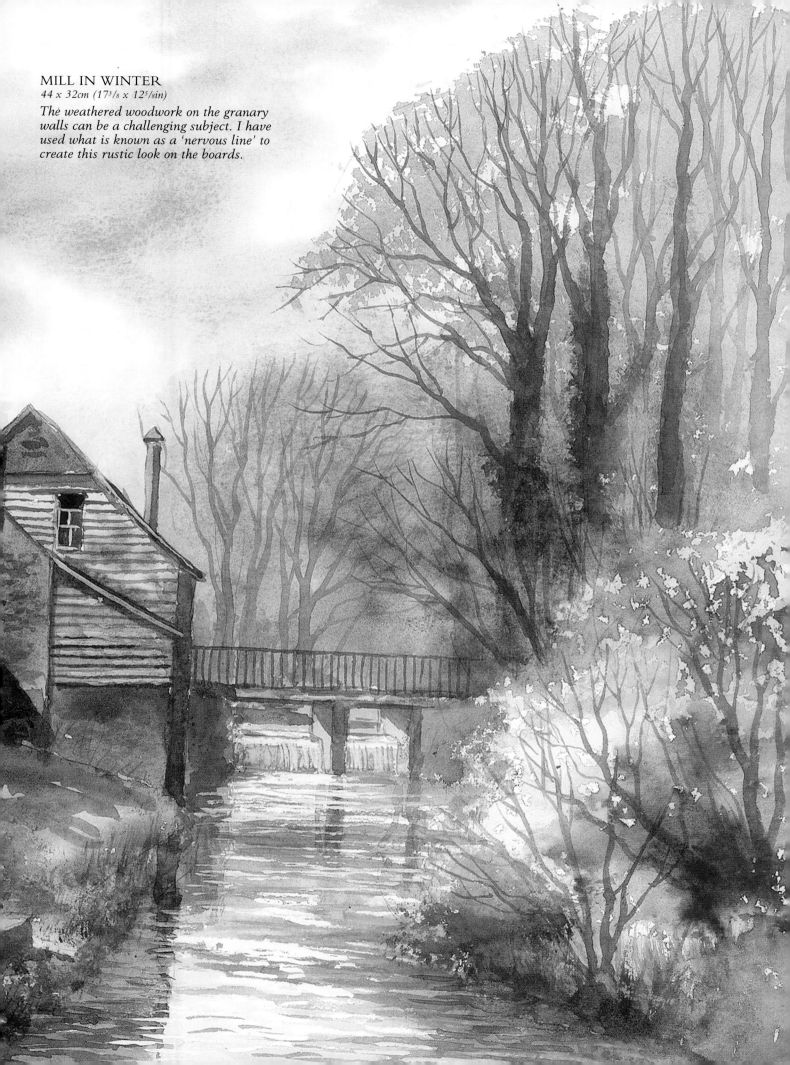

## MILL IN WINTER

*44 x 32cm (17³/₈ x 12⁵/₈in)*

The weathered woodwork on the granary
walls can be a challenging subject. I have
used what is known as a 'nervous line' to
create this rustic look on the boards.

# Cley Windmill

Plenty of time and patience should be spent applying the masking fluid in this project, since careful application will pay dividends in the end. A strong feature of this painting is provided by the foreground reeds, which are scraped out using the shaped end of an acrylic resin brush.

YOU WILL NEED

Not paper, 38 x 56cm (15 x 22in)

Masking fluid, ruling pen and ruler

Colours: French ultramarine, burnt umber, burnt sienna, cobalt blue, raw sienna, white gouache

Brushes: large mop, no. 4 round, no. 12 round, no. 8 round, brush with shaped, clear acrylic resin handle, fan brush, rigger

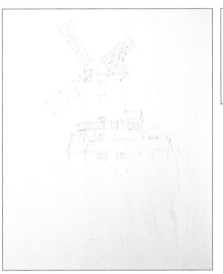

1 Draw the scene.

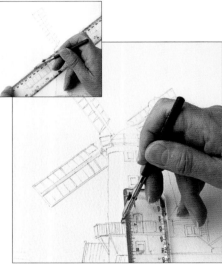

2 Use a ruling pen, a ruler and masking fluid to mask the main lines of the windmill's sails. Mask the straight lines of the walkway in the same way.

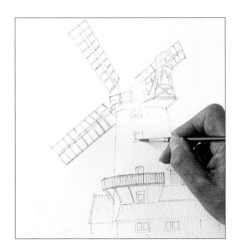

3 Use a brush to apply masking fluid around the windows.

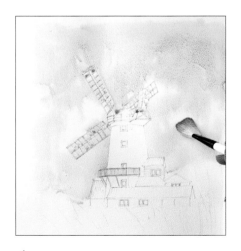

4 Use a large mop brush to paint clear water over the sky area, then drop in ultramarine.

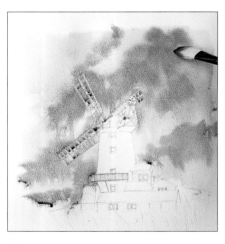

5 Drop in ultramarine and burnt umber, wet into wet. The sky behind the masked parts of the windmill should be dark and stormy.

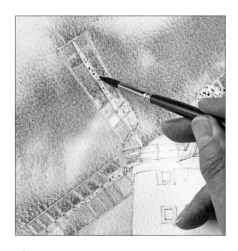

6 Use a clean, dry no. 4 brush to lift out paint if it pools in spaces between masking fluid lines. Allow the painting to dry naturally.

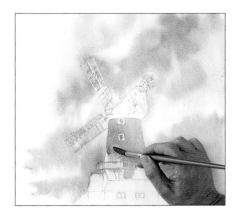

7 Paint the cylinder with the no. 12 brush and a wash of burnt sienna.

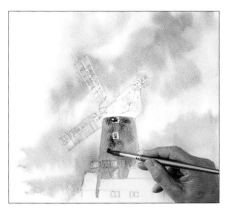

8 While the first wash is wet, drop in burnt umber.

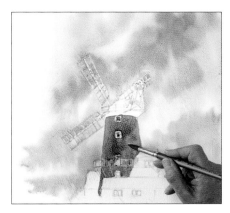

9 Still working wet into wet, drop in cobalt blue.

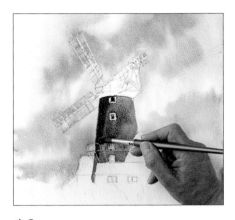

10 While the paint is still wet, paint ultramarine and burnt umber down the left-hand side of the windmill's cylinder.

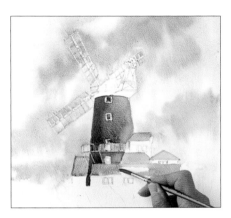

11 Change to the no. 8 brush and paint the roofs around the windmill with burnt sienna.

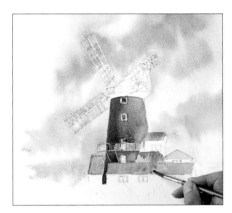

12 Drop in cobalt blue wet into wet.

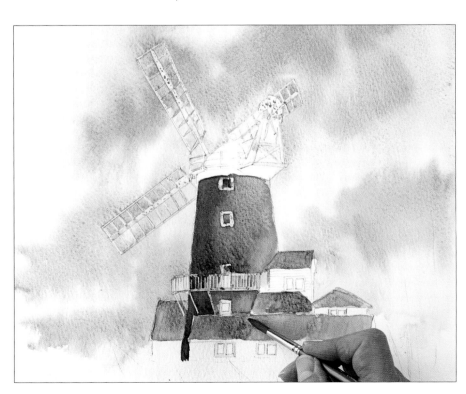

13 Drop in a stronger mix of burnt sienna wet into wet to create texture and variation. Allow to dry.

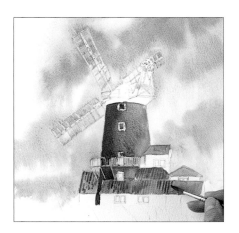

**14** Paint the tiles on the roofs with the no. 8 brush and burnt umber.

**15** Mix a light wash of burnt sienna and cobalt blue and paint the walls of the outbuildings.

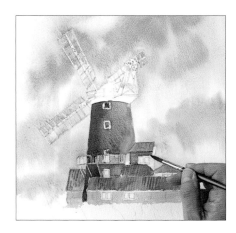

**16** Paint the outbuilding at the top right with ultramarine and burnt umber.

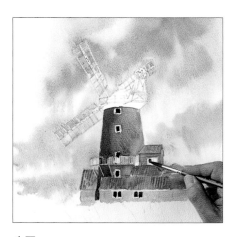

**17** Paint the darks in the windows with a strong mix of the same colours.

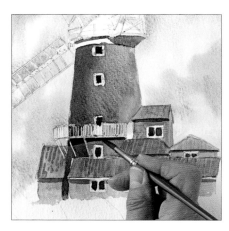

**18** Use the same mix to paint the shadows under the eaves, under the gantry at the top and under the walkway.

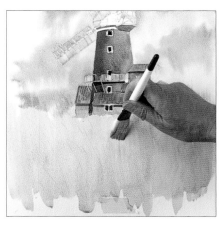

**19** Paint the reeds in the foreground with the mop brush and an initial wash of raw sienna.

**20** While the first wash is wet, paint burnt umber on top.

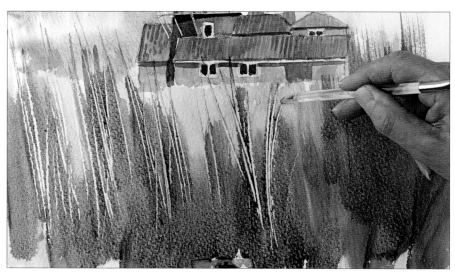

**21** Scrape out reeds using the shaped, clear handle of a special brush.

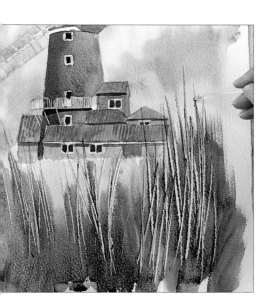

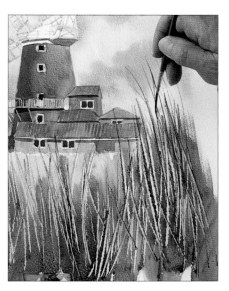

**22** Extend some of the strokes with the brush handle into the sky, and paint will be scraped upwards to create the tops of the reeds.

**23** Paint more reeds extending up into the sky area with the rigger brush and burnt umber.

**24** Use a fan brush to paint the tops of the grasses with burnt umber as shown.

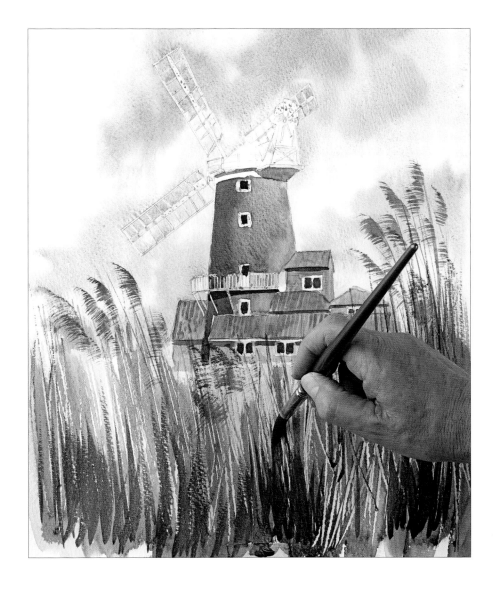

**25** Sweep up burnt umber in the foreground with the no. 12 brush to darken the base of the reed bed.

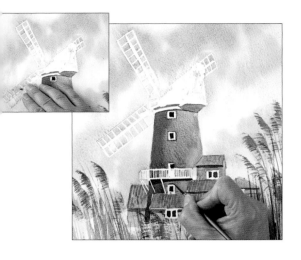

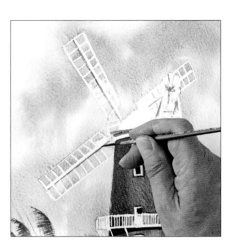

**26** Remove the masking fluid with clean fingers and use the rigger and burnt sienna to tidy up the edges which were masked off.

**27** Still using the rigger, add a bit of shadow on the workings of the windmill and the sails, with cobalt blue and a touch of burnt sienna.

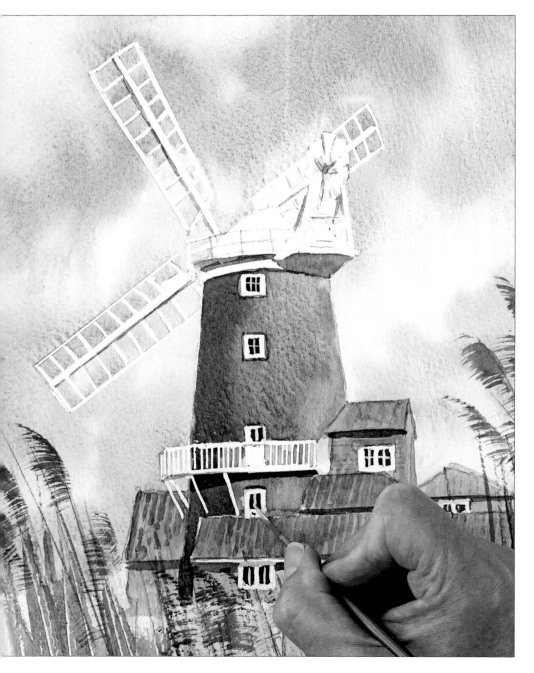

**28** Pick up white gouache on the rigger and paint light on some of the windows, and the cross bars.

*Opposite*
*The finished painting.*

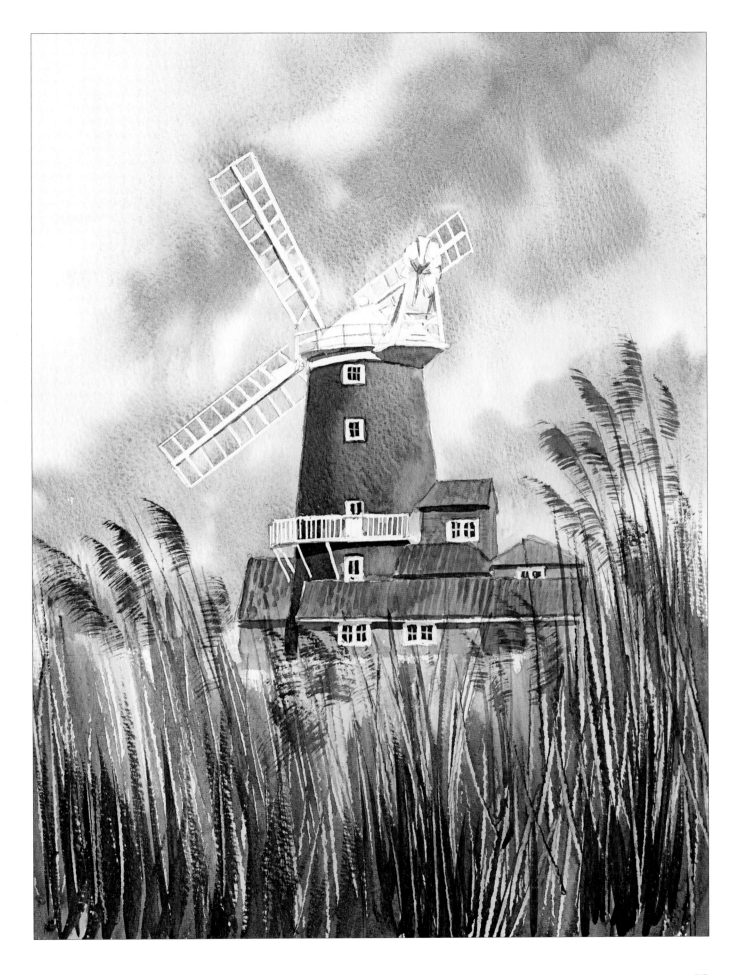

*Cley Windmill must be the most painted windmill ever, portrayed in
all seasons and from every conceivable angle. If you like windmills,
this is the one to paint. To make this painting different from the one
in the step-by-step demonstration, I have painted it at sunset, and in
the foreground I have added a little rowing boat moored in the reed
beds. In order to keep the focus on the windmill, I kept the colours of
the boat and reeds very similar and the tonal values subdued.*

## WINTER SKIES
*29 x 29cm (11³/₈ x 11³/₈in)*

*I have chosen to paint the mill with a dark, stormy sky, which contrasts
strongly with the white windmill sails. To add interest to the foreground I have
painted some dried cow parsley in the hedgerow.*

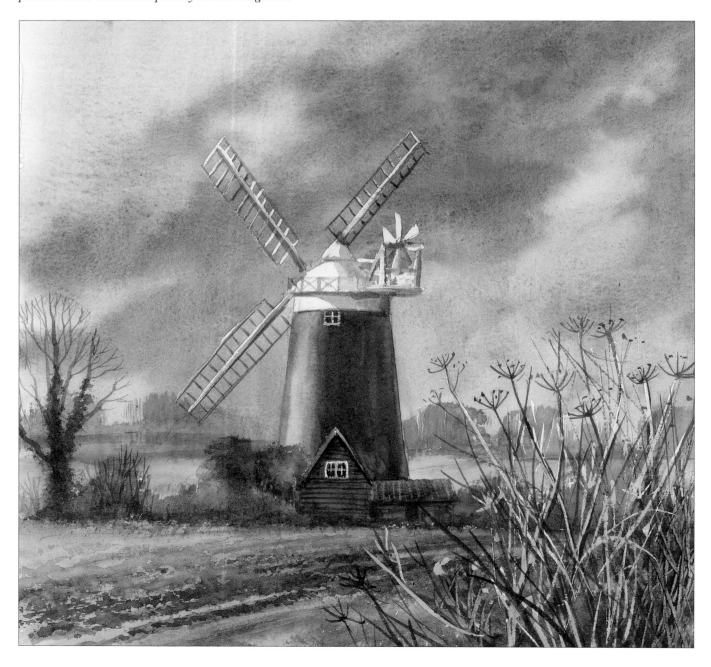

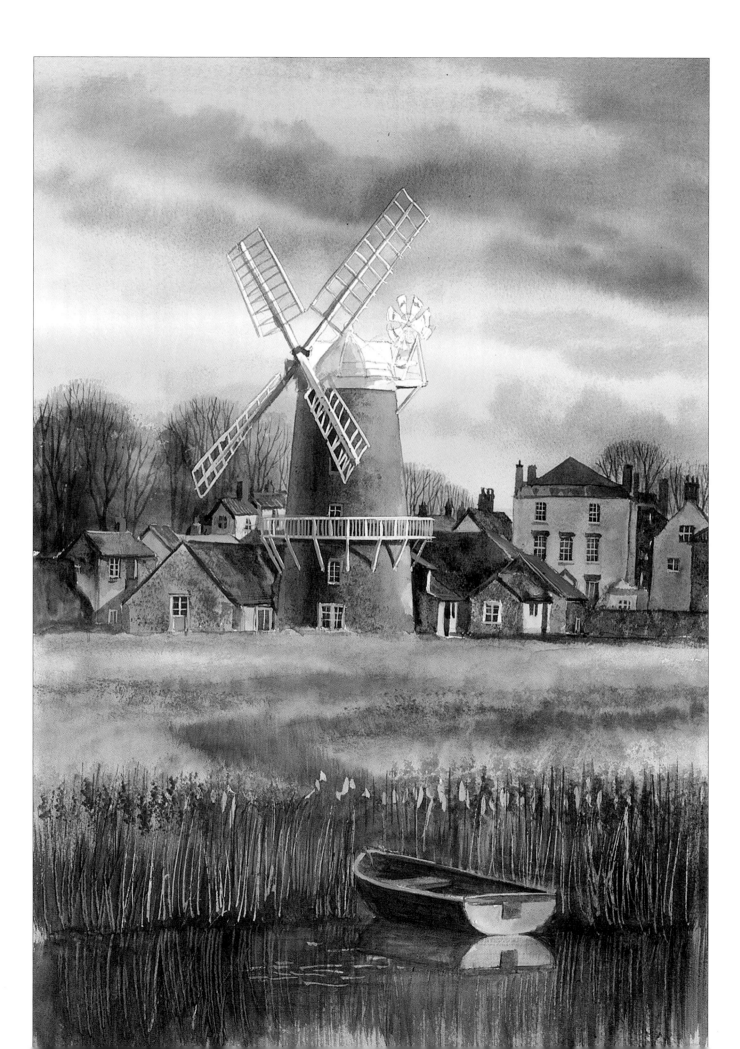

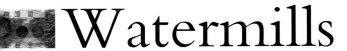# Watermills

Once commonplace but now a rare sight, the watermill is a nostalgic
reminder of a bygone age, in a picturesque setting by the water's edge.
If you are painting a watermill, it is more than likely that you will
have to paint water. Use this as an advantage by positioning yourself
so that you can take advantage of the reflections of the mill.

*Opposite*
BOSHAM MILL
*32 x 47cm (12⁵/₈ x 18½in)*

*This rear view of the watermill at
Bosham shows the reflections in
the slow flowing mill stream where
almost half of the painting is water.*

MUSEUM PIECE
*33 x 28cm (13 x 11in)*

*This working mill has been relocated, restored and rebuilt in the grounds
of the Weald and Downland Museum at Singleton in Sussex. They even sell
biscuits there made from the ground flour from the mill.*

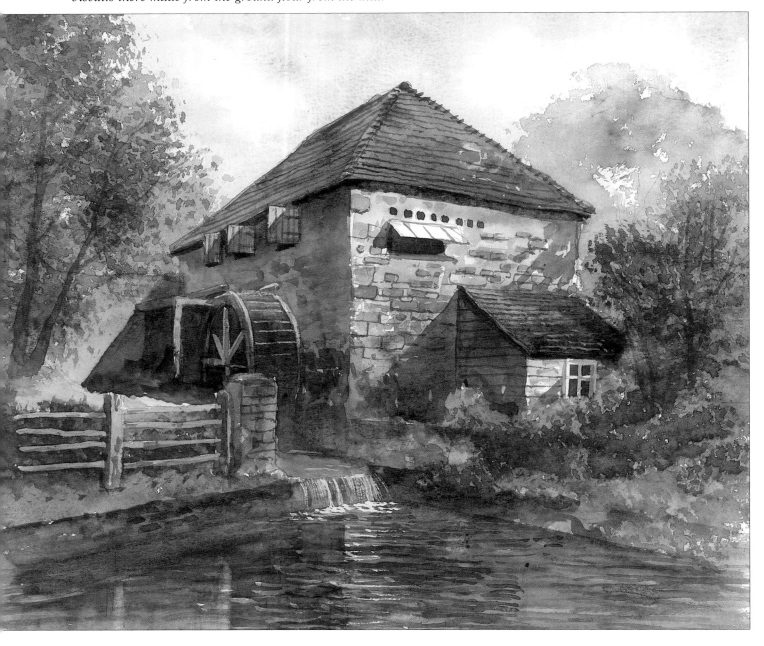

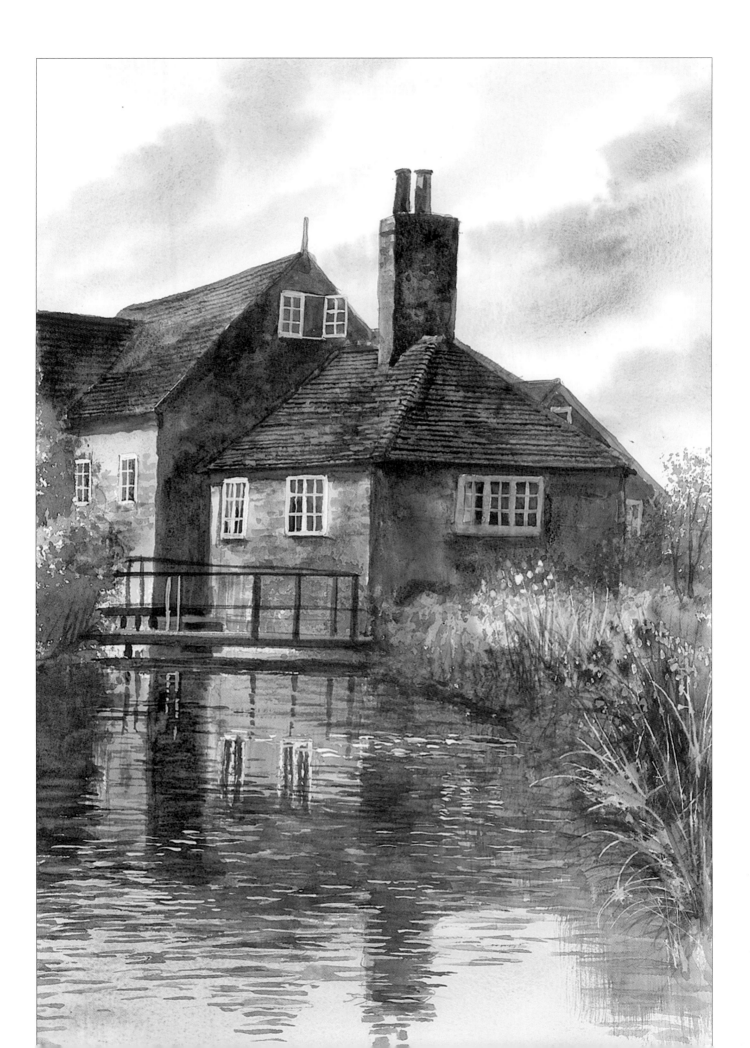

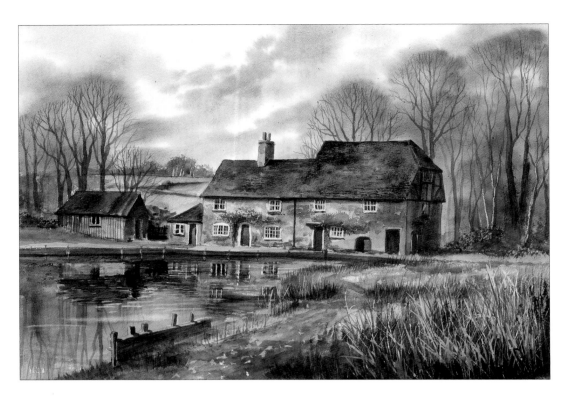

## GREYWELL MILL
*52 x 34cm (20½ x 13³/₈in)*

*This mill is set at the head of the River Whitewater, the first of many mills on this river which eventually flows into the River Thames. This view emphasises the river bank, but by repositioning yourself at the water's edge, you can make more of the reflections.*

## SUFFOLK MILL
*40 x 30cm (15¾ x 11¾in)*

*Masking fluid was used to create the foreground grasses, trees and ripples in the water, including the white reflections of the mill. However, the building itself was left as white paper with the panel detail added with a rigger brush.*

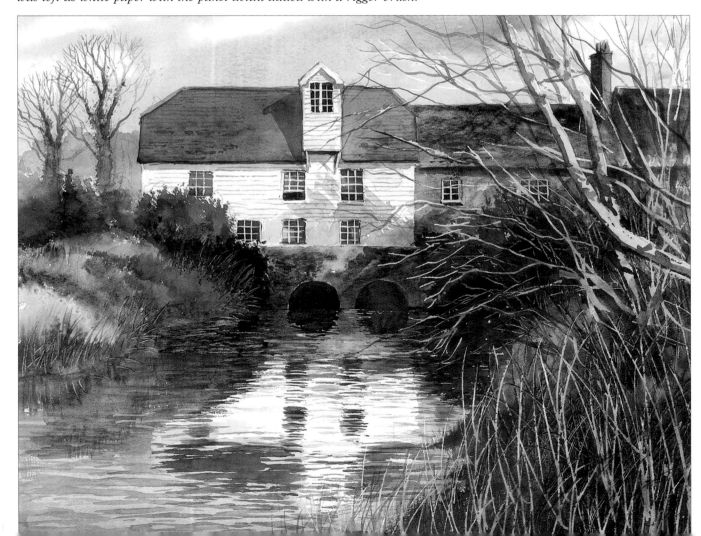

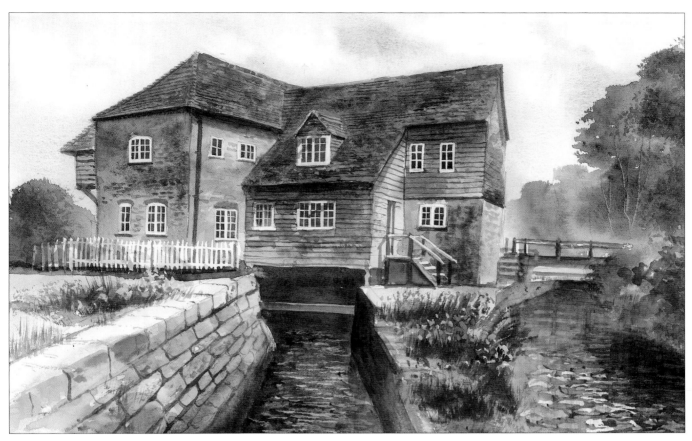

## BOSHAM MILL FROM THE QUAY
*46 x 30cm (18¹/₈ x 11¾in)*

*Like most mills this is no longer working – it is the home of the local yacht club. The mill therefore remains in use and the public can enjoy it, albeit, as members of the club.*

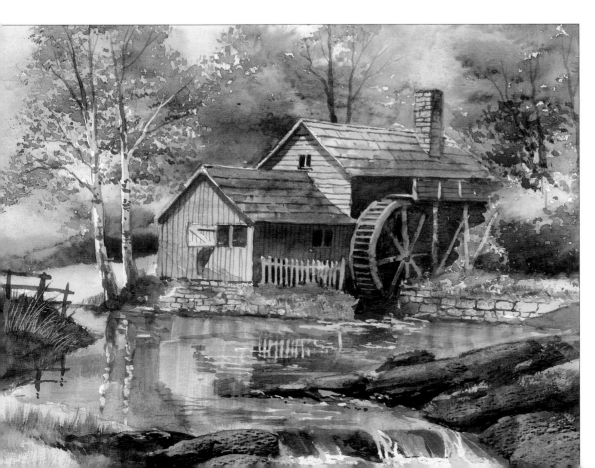

## HIGH COUNTRY MILL
*41 x 31cm (16¹/₈ x 12¼in)*

*This mill is in a country park in North Carolina USA. I have used the building as reference, but changed its surroundings. For the detail on the water wheel and the fence I have used masking fluid, and the texture on the rocks was created by scraping out wet paint with a plastic card.*

# SHEDS, SHACKS & HUTS

Not all buildings have to be grand to warrant painting; humble garden sheds, outhouses or fisherman's huts make fabulous subjects for a painting.

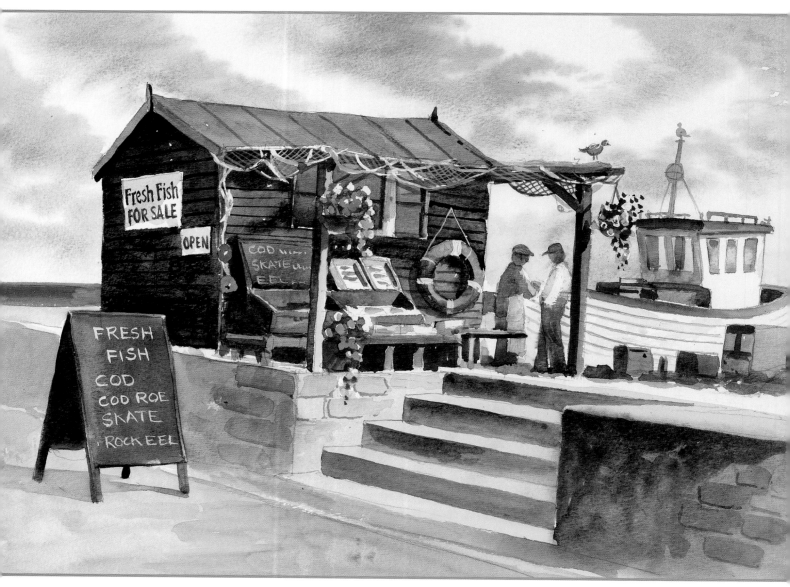

**THE FISH SHACK**

*48 x 32cm (18⁷/₈ x 12⁵/₈in)*

*This Fisherman's Fish Shop is set high on the beach with a fishing boat resting next to it, with fishing nets, a life buoy and seagulls setting the scene and hanging baskets adding a splash of colour to this salty subject.*

## AT THE BOTTOM OF THE GARDEN
*19 x 31cm (7½ x 12¼in)*

*This garden shed is surrounded by colour and a little neglect. A delightful subject to paint.*

## SPANISH SHACK
*25 x 19cm (9⅞ x 7½in)*

*Dotted around the Spanish countryside you can find little mini barns full of rustic charm and character. Set in an overgrown smallholding, this makes a perfect subject.*

67

## CAUTION, MAN AT WORK
*22 x 29cm (8¾ x 11³/₈in)*

*A shed at the bottom of the garden is, for some people, heaven – a retreat from reality and a place to do 'man things'. I would call it a studio. The open door gives you a glimpse into another world so that the painting suggests a story and includes a personal element.*

## RUSTY ROOF
*41 x 25cm (16¹/₈ x 9⁷/₈in)*

*High on the moors, this windswept outhouse is just hanging on to usefulness. The rust-red tin roof can lift a painting with a much needed touch of colour, whereas hanging baskets and flower pots would be out of place on this remote moor.*

## LOG CABIN RETREAT
*29 x 39cm (11³/8 x 15³/8in)*

*In America the log cabin has long been a symbol of getting away from it all – a place to return to nature. The shaded foreground emphasises the sun on the cabin.*

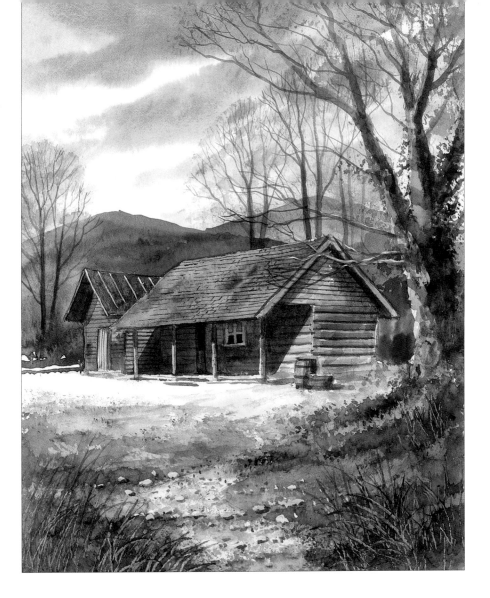

## THE WOOD SHED
*30 x 14cm (11¾ x 5½in)*

*The tin roof is the main feature of this painting. Masking fluid was used on the ridges of the tin sheets and the rust was painted wet into wet.*

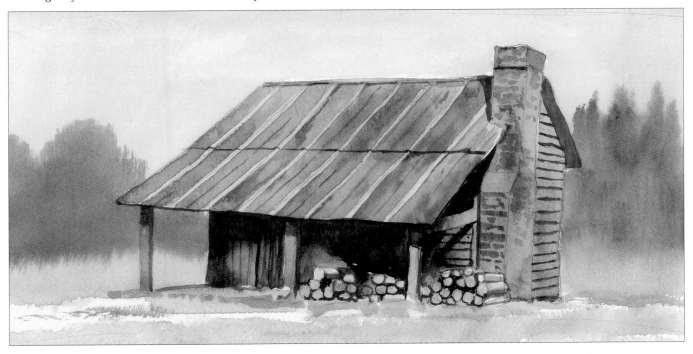

# BARNS

There is something about barns, especially old rustic barns. The more weathered and neglected they are, the more beautiful they become. In this chapter I have selected a cross section of barns from all over, in many different shapes, sizes and styles, in the hope that they will inspire you as they inspire me.

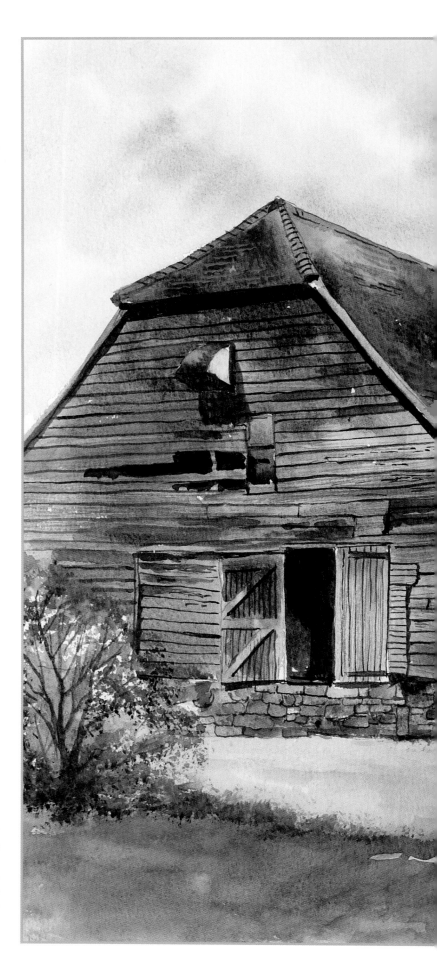

ANCIENT SUSSEX BARN
*58 x 42cm (22⅞ x 16½in)*

*What I love about this painting is the detail. I know I should be telling you not to fiddle with a painting, but embellishing is another matter. Using a rigger brush, I have embellished the weatherboards, roof tiles, brickwork and even the winter trees.*

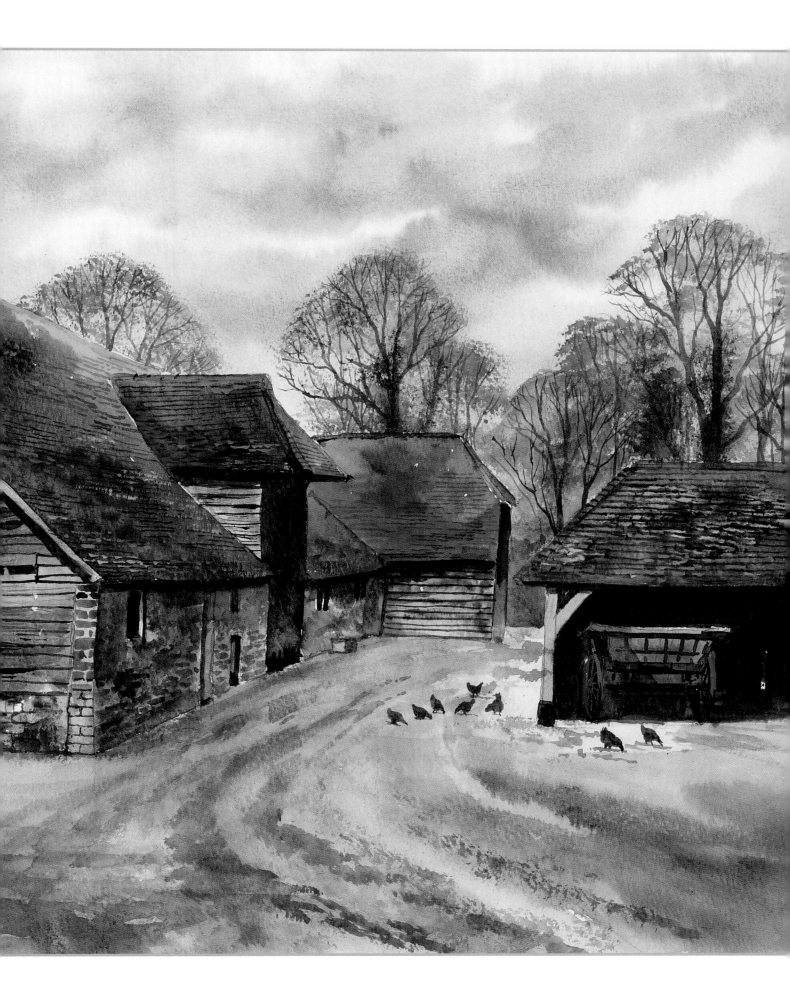

# Barn roofs

The material used on barn roofing can vary from region to region, depending on what was available locally. Sadly the cost of reproofing can result in some beautiful roof tiles being replaced with concrete tiles or corrugated tin – but at least tin roofs have a certain rustic appeal.

*Shown here is a selection of colours that are useful when painting rust. You do not have to use all the colours at the same time; to get the best results, use only two or three colours and merge them wet into wet.*

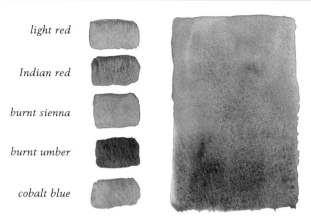

light red

Indian red

burnt sienna

burnt umber

cobalt blue

## A corrugated tin roof

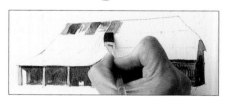 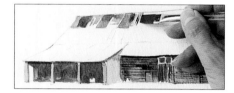 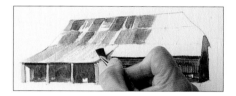

1 Use the 13mm (½in) flat brush to paint diagonal downward strokes of burnt sienna, then introduce cobalt blue wet into wet.

2 Use the straight edge of the brush to suggest corrugation.

3 Continue painting sections of the roof in this way to create a patchy effect. Change to light red lower down.

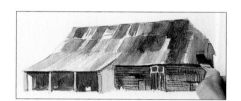

4 Paint more burnt sienna on the right-hand side of the roof. Allow to dry.

5 Use the rigger brush and burnt umber with ultramarine to paint the vertical and horizontal details.

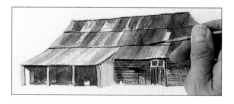

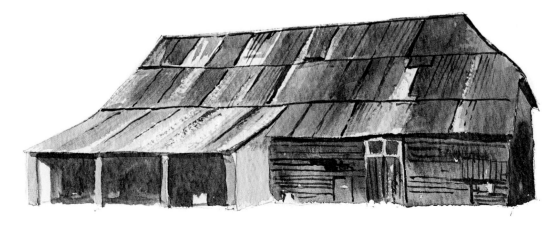

*The finished barn.*

# A flat tin roof

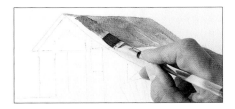

1 Paint the roof with Winsor orange and ultramarine on the 13mm (½in) flat brush.

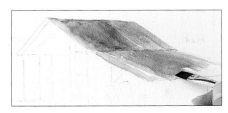

2 Add burnt sienna to the mix to paint the bottom panel, and leave some white.

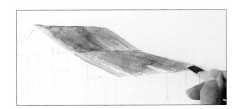

3 Add ultramarine to the mix and continue painting wet into wet. Allow to dry.

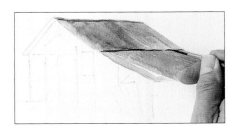

4 Paint the horizontals with the rigger brush and burnt sienna with ultramarine.

5 Finally paint the diagonal lines following the slope of the roof with Winsor orange and ultramarine.

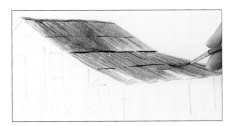

*The finished barn.*

# A tiled roof

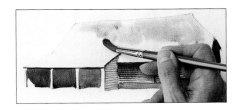

1 Wet the roof area with the no. 12 brush and drop in burnt sienna.

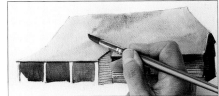

2 Drop in cobalt blue wet into wet.

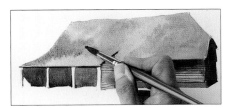

3 Drop in burnt umber in the same way.

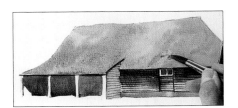

4 Still working wet into wet, touch in olive green in the lower half of the roof to suggest moss.

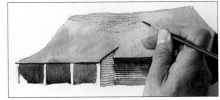

5 Use the rigger brush and burnt umber to paint uneven lines suggesting old tiles on a sagging roof.

*The finished barn.*

## A thatched roof

Thatched barns were once common, but they are now a rare sight. Now the roofing is replaced with a cheaper material, which is a shame. This barn in Worcestershire looks almost toy-like with its neatly trimmed thatch. The rustic weatherboarding adds lots of detail and interest, and note the planks missing on the wall and the uneven woodwork on the doors.

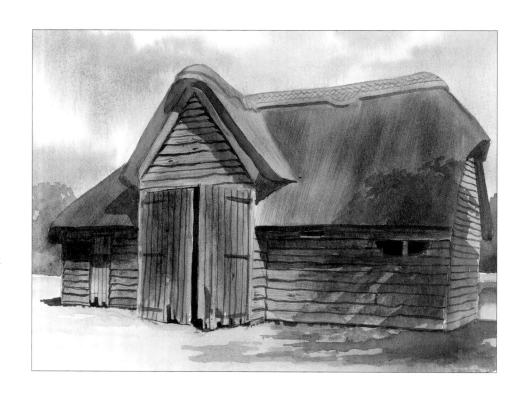

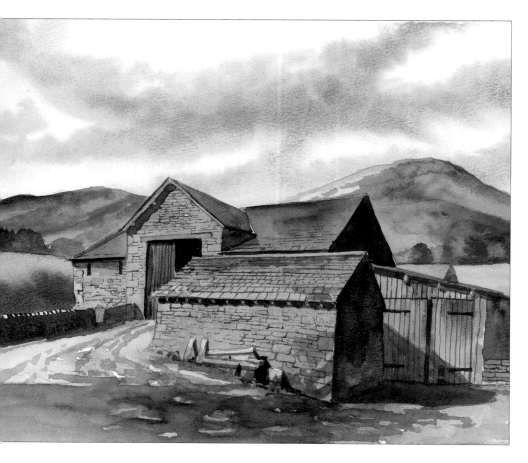

## A slate roof

This Lakeland farmstead near Coniston is typical of the barns in Cumbria, which are made from local granite and look as if they will stand forever. The slates are from a local quarry and are sold by the ton. The ridge tiles are made of clay adding a contrast in colour to the blues and greys of the slate.

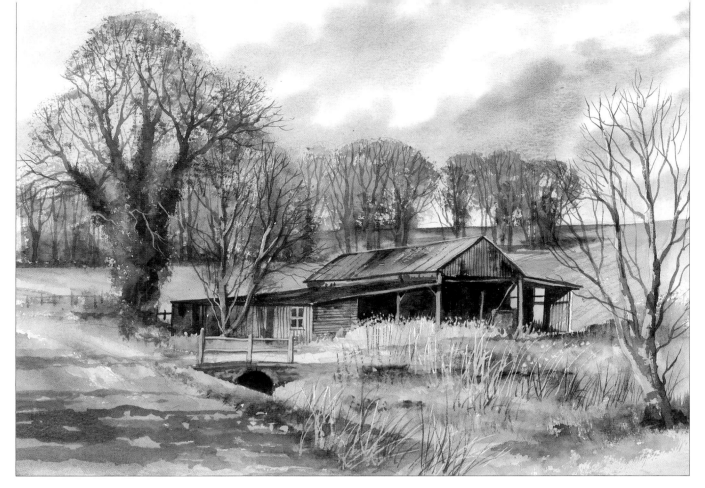

## A tin roof

Not all barns are built to last; this tin-roofed barn in Hampshire looks as if it has seen better days. The rust-red roof creates a focal point, with lots of burnt sienna and cadmium red put to good use to create a colourful imact.

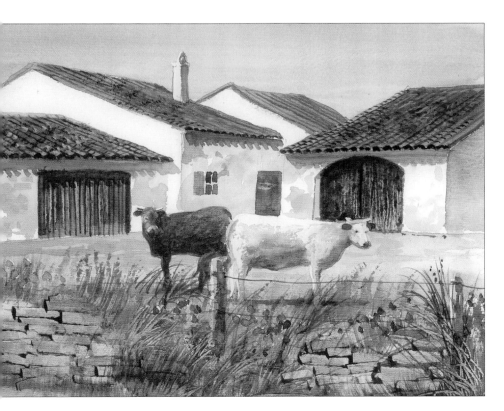

## A pan-tiled roof

These Spanish barns were built to weather the hot summer sun. The white-washed walls reflect the heat and the shallow angled roofs offer some welcome shade.

# Barn walls

Weather-beaten wood on the side of an old barn, aged by harsh, cold winters and bleached by long hot summers is an unusual choice of painting subject. The challenge of painting wood is not as difficult as it may look.

*These colour mixes can be useful for weathered wood: on the left, cobalt blue and burnt sienna and on the right ultramarine and burnt umber.*

## Painting woodgrain

1 Draw the woodgrain first. Then take the no. 12 brush and drag a wash of burnt sienna down the paper.

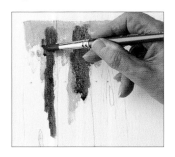

2 Drop in burnt umber wet into wet and drag it down the paper in the same way.

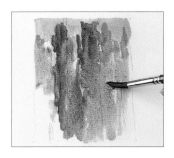

3 Mix burnt umber and ultramarine and paint this at the bottom, using the dry brush technique to create texture. Allow to dry.

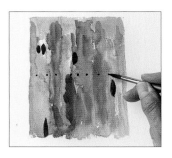

4 Use the no. 8 brush and ultramarine with burnt umber to paint knots and nail holes wet on dry.

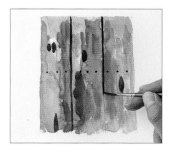

5 Use the rigger brush and a stronger mix to divide the background colour into planks.

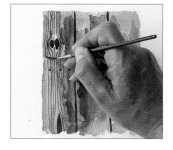

6 Paint the grain of the wood. Bring the line down to the knot, go round it and continue down. The next line out should be a little less curved, and so on.

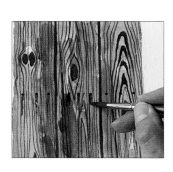

7 Use the no. 8 brush and burnt sienna to paint rust around the nails.

*The finished woodgrain.*

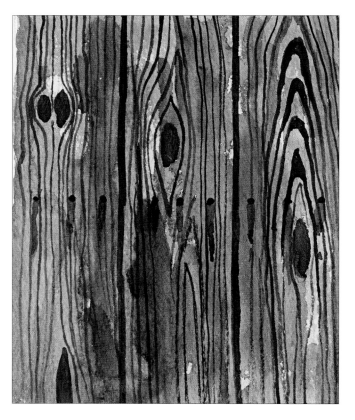

*If you are looking for reference for woodgrain, just glance around you at home; there is woodgrain on doors, cupboards, tables and floorboards.*

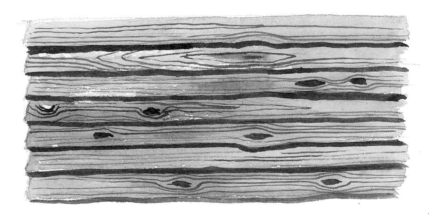

*Aged and weathered wood is often a silver colour and not necessarily brown. To achieve this effect, you could use a blue and a brown to create a suitable silver or grey – for example, mix ultramarine and burnt umber or cobalt blue and burnt sienna; then whilst the mix is still wet, drop in a touch of green or raw sienna to add rustic colour.*

# Barn doors

Whatever the shape or type of barn, the entrance used to have to be large enough to drive a horse and cart through. A typical barn would have two doors, one at the front and the other at the other side of the threshing area. The main door would be larger, allowing a fully laden cart to enter, unload, and then exit at a smaller rear door. To help ventilation, some doors have variable openings, hinged in sections to allow a through draught, so by varying the openings the air circulation in the barn can be controlled. I guess that is where the expression comes from when a door is left open, 'Close that door! Were you born in a barn?'

RUSTY TIN PORCH
*34 x 40cm (13³/₈ x 15¾in)*
*The rich rust colours contrast with the softer mellow tones of the old weathered door. Note the sophisticated door fastenings.*

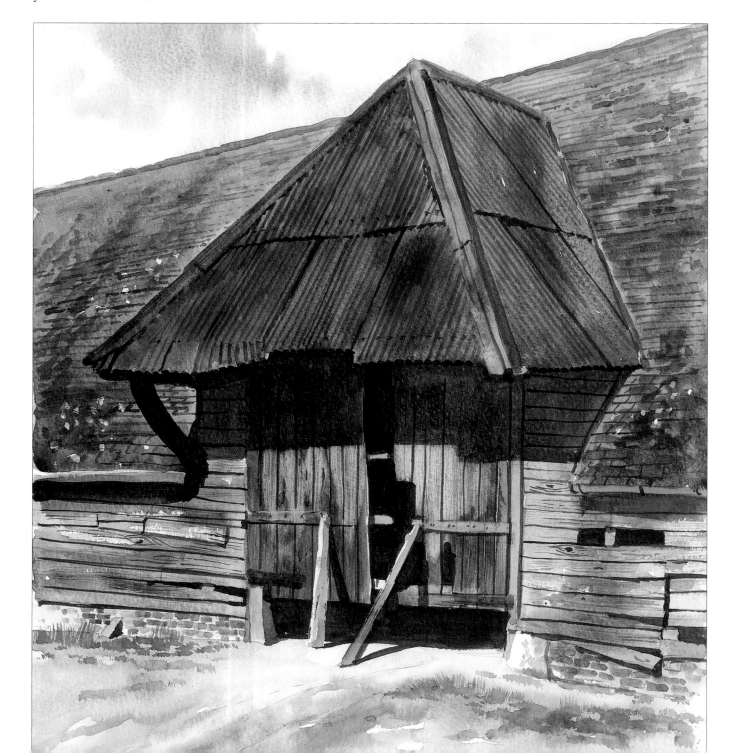

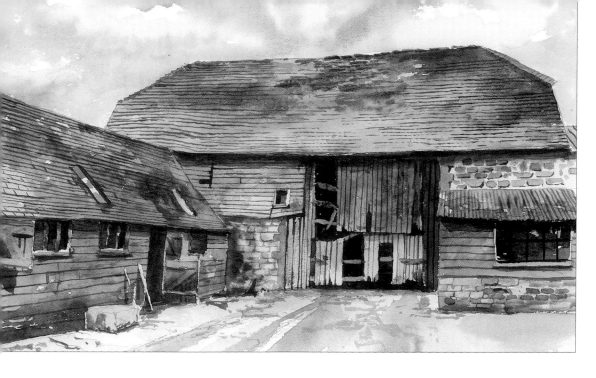

### HANGING ON
*33 x 22cm (13 x 8⁵/₈in)*

*This ramshackle old barn has a slight ventilation problem! A light wash of soft greens adds to the look of rustic neglect on the vented door.*

### THE RUSTING WHEELBARROW
*31 x 24cm (12¼ x 9½in)*

*The entrance to this barn is called a gabled porch. The raised platform in front of the door allows carts to unload straight into the barn. The upturned wheelbarrow in the foreground also adds a little rustic charm.*

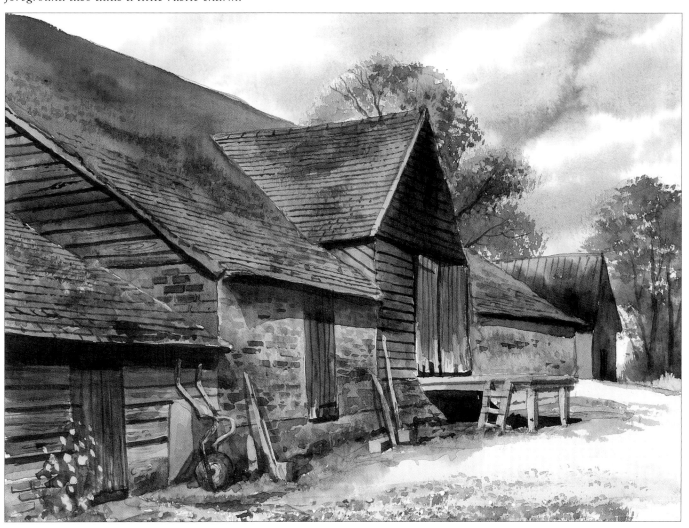

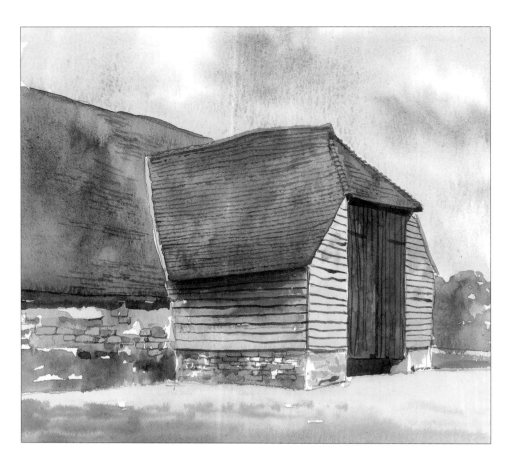

## HALF–HIPPED PORCH
*24 x 21cm (9½ x 8¼in)*

*This style of barn entrance is called a half-hipped porch. The hip is the triangular sloping roof on the front of the porch, or on the end of a barn roof.*

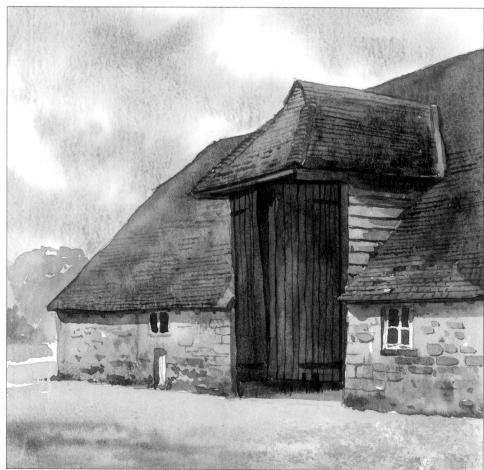

## A HIPPED PORCH DESIGN
*23 x 23cm (9 x 9in)*

*Barn doors often have a large gap at the bottom. Threshing boards were once placed across the entrance to ensure that the wheat remained in the threshing area inside the barn. This is the origin of the term 'threshold'.*

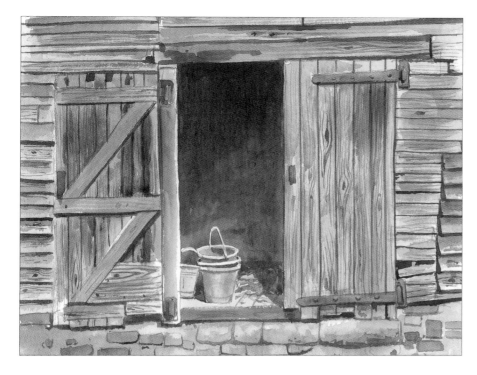

## THE OPEN DOOR
*24 x 20cm (9½ x 7⅞in)*

*A close-up study of a doorway can be as challenging as painting a whole barn. The feed buckets just inside the opening lead the eye into the dark unknown.*

## UNHINGED
*33 x 22cm (13 x 8¾in)*

*It is the closely observed detail that adds to this finished painting. A hint of green helps to age the woodwork on the old pigsty door.*

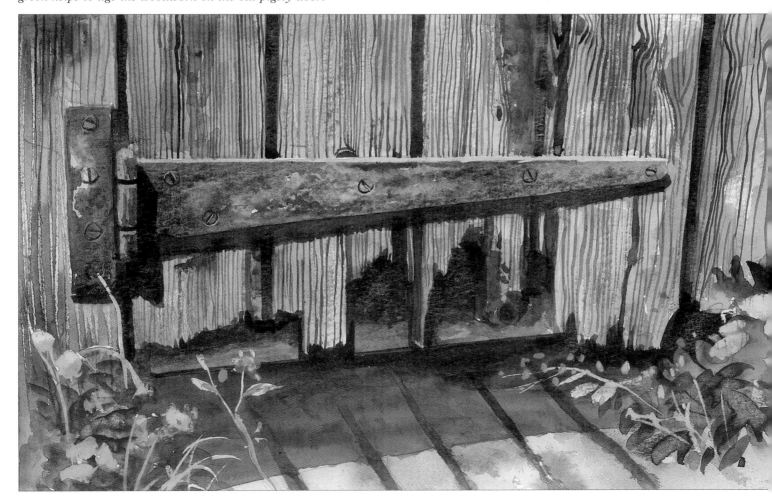

# Other structures

A lean-to is not the most inspiring of structures, just an extension or an after-thought tagged on to an existing building or barn to add storage space. It is the suggestion of what lurks inside that makes the painting interesting.

*Opposite*
THE CART SHED
*34 x 23cm (13³/₈ x 9in)*
*This rustic add-on provides some much needed shelter for cherished farm equipment.*

THE OLD AND THE VERY OLD
*38 x 31cm (15 x 12¼in)*
*This French shelter houses a combination of the very rustic and the rapidly becoming rustic.*

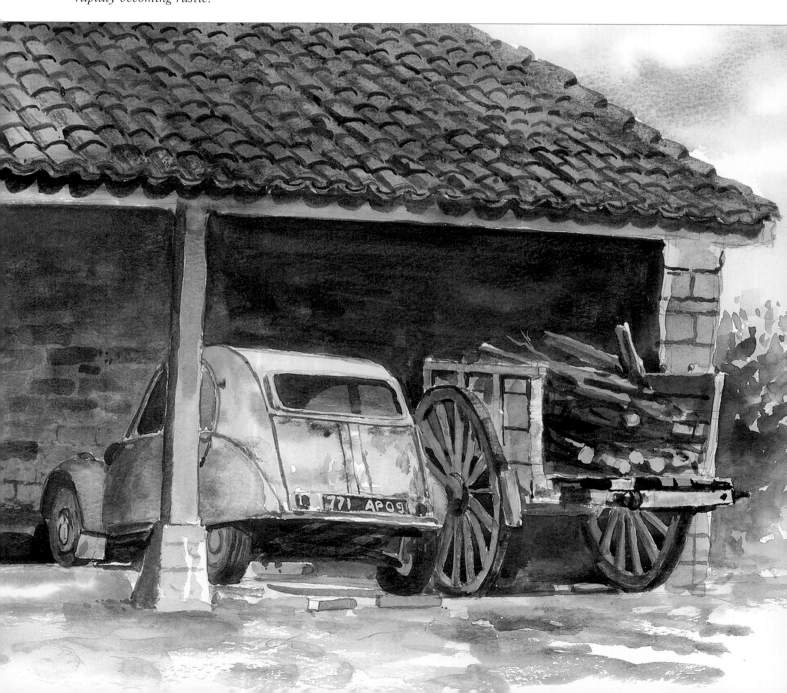

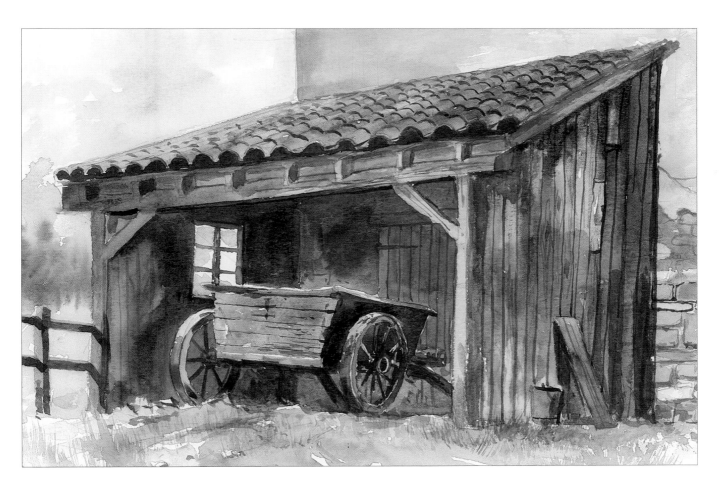

## RUSTIC BED & BREAKFAST (FULL)
*37 x 27cm (14½ x 10⅝in)*

*I couldn't resist painting this rustic lean-to, but what makes it amusing to me is the forgotten sign, still hanging, a reminder of better days.*

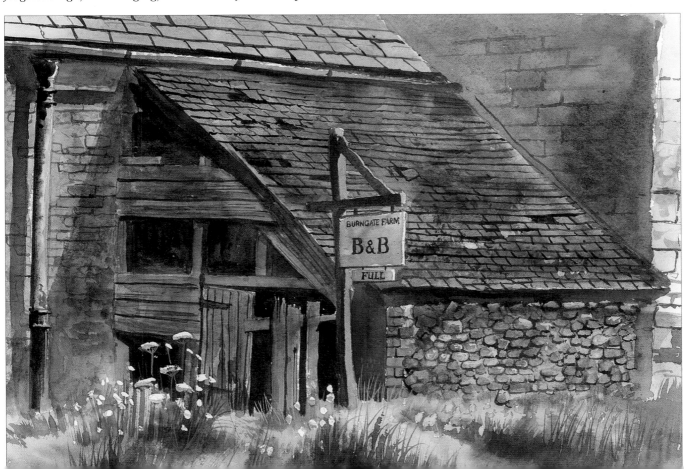

# Oast houses

Scattered around the countryside of South-East England (but mostly Kent), oast houses like those shown on these pages can easily be spotted by their distinctive conical roofs and white cowls. Oast houses were used in the production of beer. Hops were dried out in the conical kilns, then shipped off to the brewery. Nowadays most oast houses have been converted into desirable residences.

When painting oast houses, it is important to have the kilns upright and not leaning over. A simple way of achieving this is to divide the kiln in two, with a line drawn up the centre to ensure that each half is drawn symmetrically. From the top of the kiln walls, draw the roof lines so that they converge at the same point on the centre line. The white ventilation cowls which sit on top of the roofs slope at a slightly different angle to the roof and rotate to allow for ventilation.

**WEATHER ANOTHER WINTER**
*52 x 36cm (20½ x 14⅛in)*

*The maintenance on weatherboarded barns and oast houses must be expensive, but neglect can lead to a very rustic-looking paint effect!*

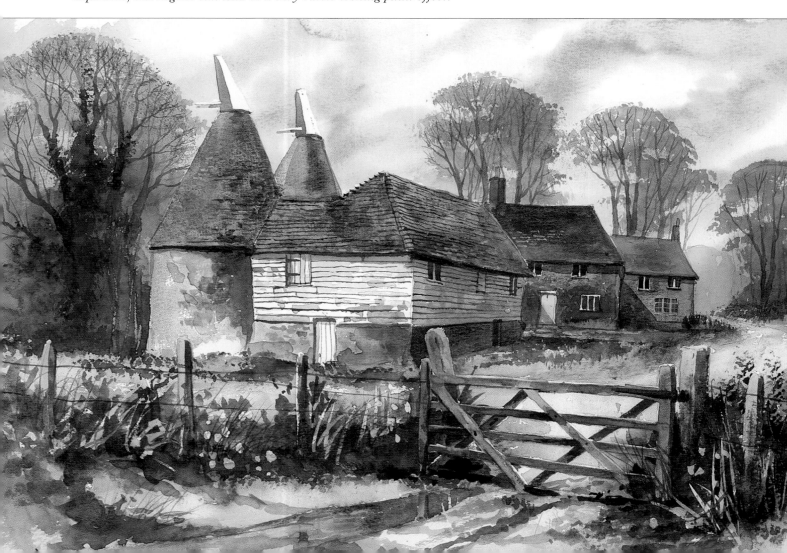

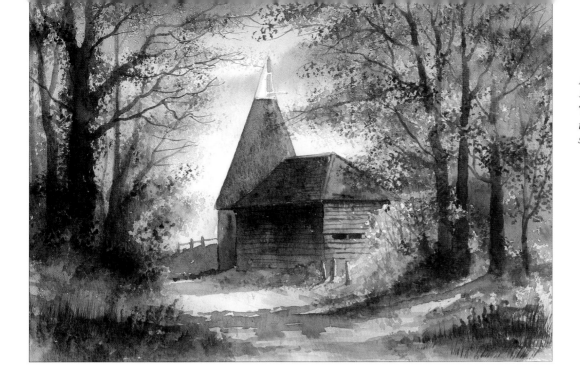

**AUTUMN SHADES**
*37 x 27cm (14½ x 10⅝in)*
*The autumn trees help to frame the iconic shape of this old oast.*

**SUMMERTIME**
*38 x 26cm (15 x 10¼in)*
*The white barns and cowls create a striking focal point. A top tip is to use masking fluid on the white cowls.*

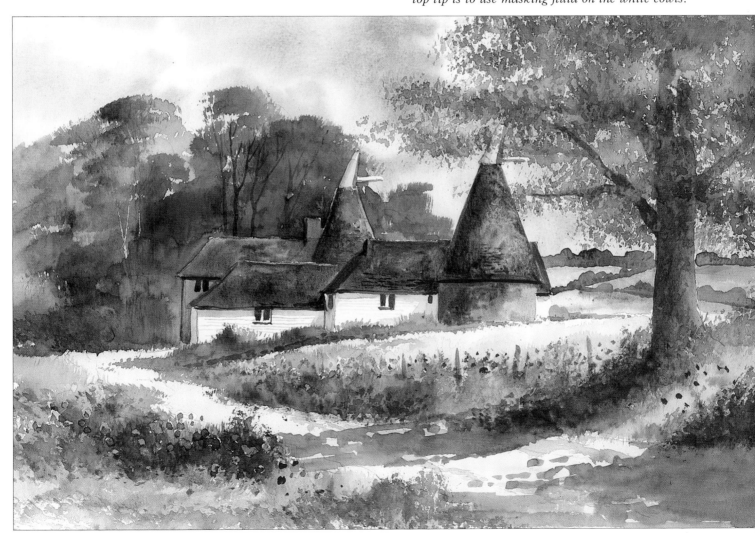

# Very rustic barns

To some people, a crumbling building or barn is an eyesore, but to an artist it represents an opportunity to create a masterpiece.

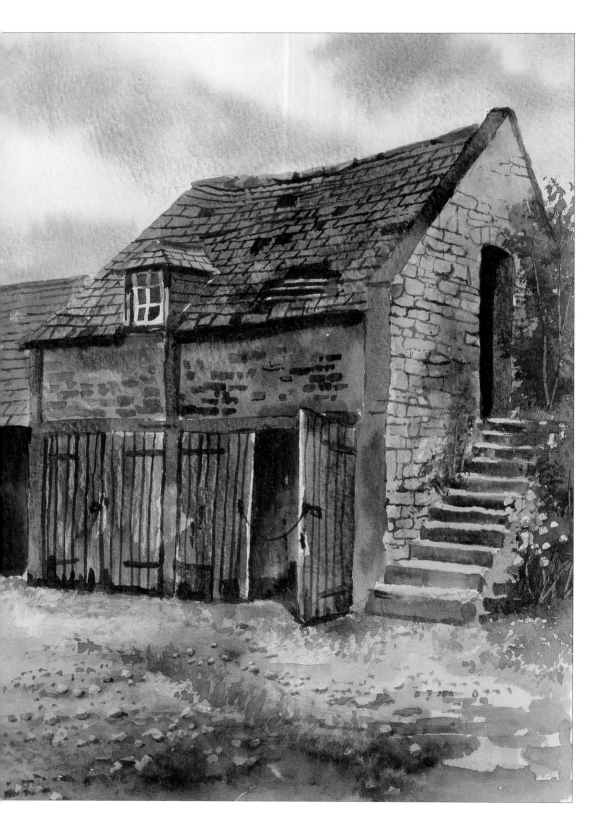

**HOTCHPOTCH FARM**
*25 x 36cm (9⁹⁄₈ x 14¼in)*
*This ramshackle barn in the Cotswolds hosts a whole array of building styles: a slate roof on a timber frame, infilled with red brick and a Cotswold stone gable with outside stairs leading to the hay loft.*

## FRENCH CHIC
40 x 26cm (15¾ x 10¼in)

*Scattered over the roof of this rustic French barn are large rocks placed in a vain attempt to keep the roof on. The rusting tin panels on the walls add to the neglected effect. The weathered walls were painted with a combination of burnt umber, ultramarine, cobalt blue and raw sienna using the wet into wet technique.*

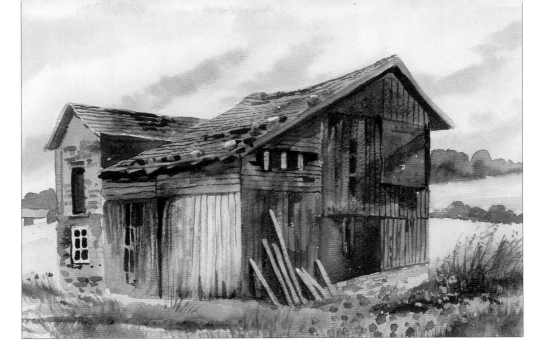

## HIGH COUNTRY, LOW MAINTENANCE
41 x 27cm (16⅛ x 10⅝in)

*This American barn with its windswept tin roof was painted wet into wet using burnt sienna, Indian red and cobalt blue. The woodwork was cobalt blue and burnt sienna and the dark shadows and details were achieved using ultramarine and burnt umber.*

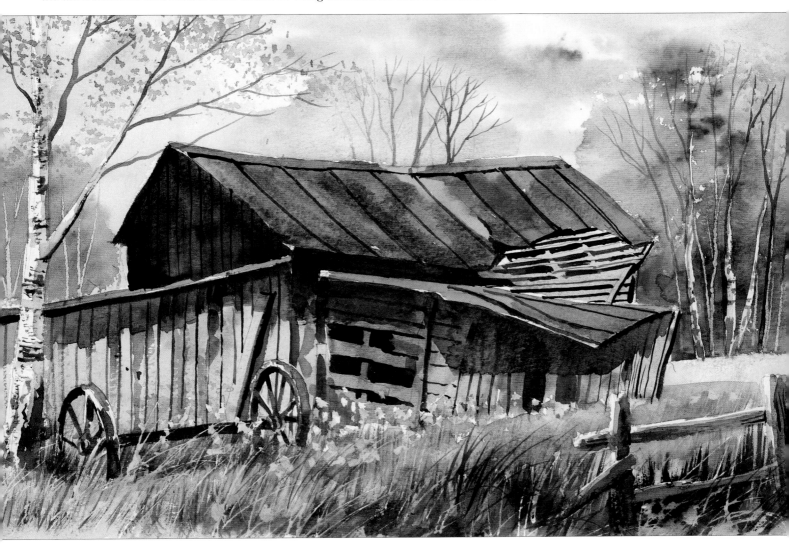

# Farmyard bits & pieces

Sometimes unexpected bits of farming equipment can be found hidden away in a forgotten corner. These can make ideal subjects in their own right. A wine cart amongst the poppies or an old tractor slowly rusting in the long grass are perfect examples, shown below.

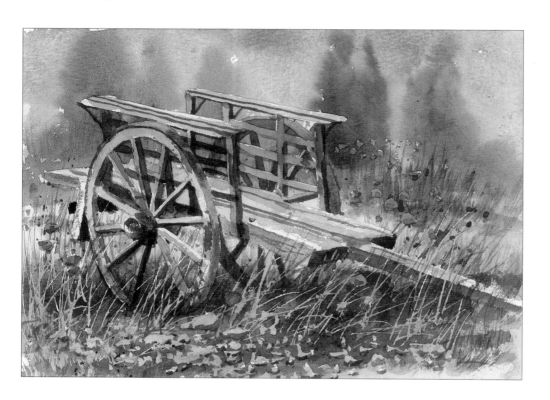

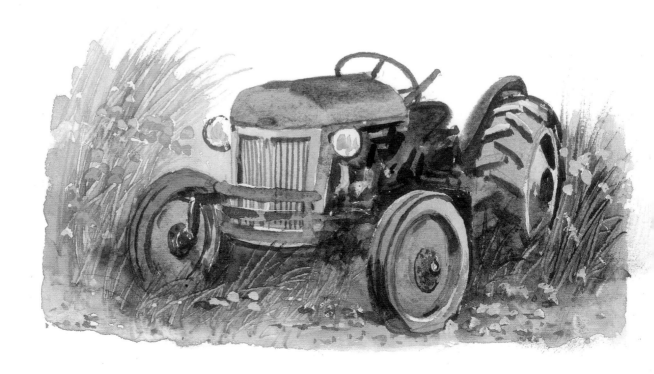

*Sometimes painting a pretty cottage or a rustic barn is not quite enough; your painting needs something extra such as some farmyard clutter – perhaps an old cart in the foreground.*

# Adding life

Introducing a living creature into a painting can make such a difference. This could be anything, such as chickens feeding, sheep in a field or a man walking a dog. Adding life adds scale to a picture, and chickens or geese in a farmyard can turn a mundane picture of barns or buildings into a living, working farm. When people are added to a scene, it can start to tell a story: perhaps a girl tending the chickens or feeding the geese. By dressing her in period costume, you can add another twist to the tale. In Victorian England, farm workers and labourers in everyday situations were popular subjects for paintings.

## Animals

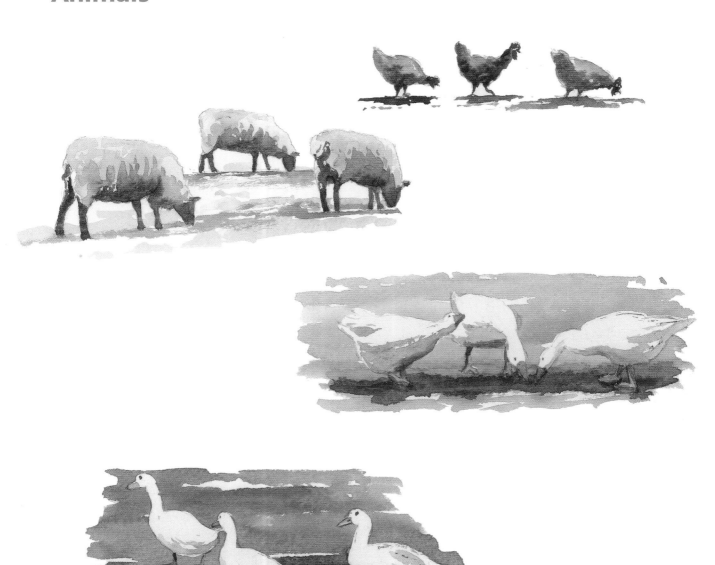

# Figures

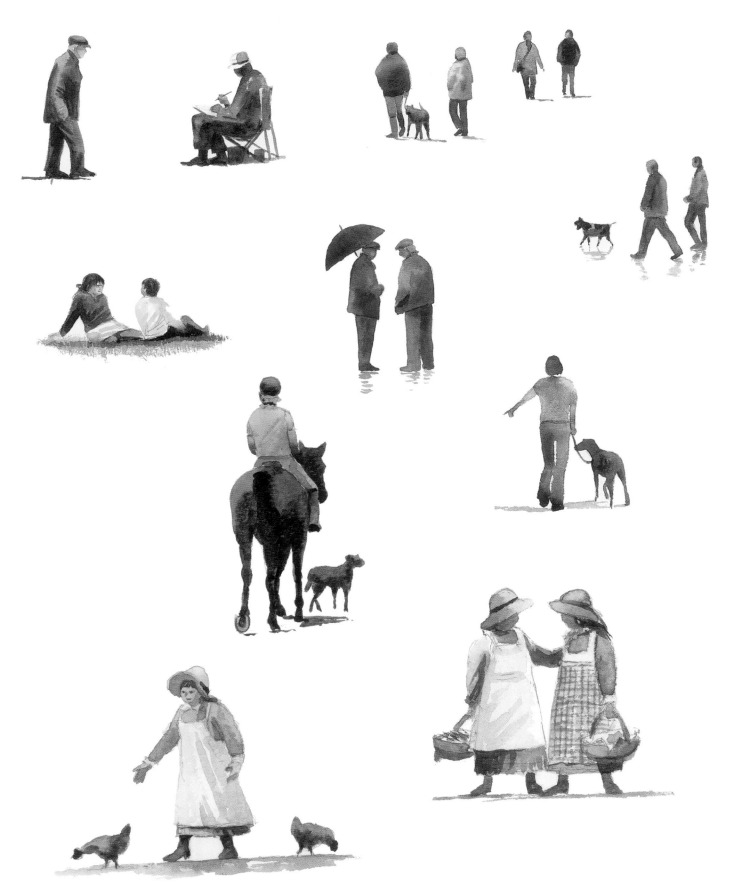

# English Barn

This step-by-step project is not based on just one barn but includes lots of different elements which combined together create a painting of a typical English barn. The open barn doors reveal a hay cart, the wooden gabled porch and roof have a hint of moss, while chickens and rusting milk churns provide a little added interest.

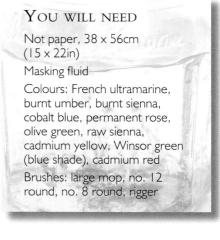

**YOU WILL NEED**

Not paper, 38 × 56cm (15 × 22in)

Masking fluid

Colours: French ultramarine, burnt umber, burnt sienna, cobalt blue, permanent rose, olive green, raw sienna, cadmium yellow, Winsor green (blue shade), cadmium red

Brushes: large mop, no. 12 round, no. 8 round, rigger

1 Draw the scene.

2 Apply masking fluid to the flowers, the cart, the window frames and the fence.

3 Wet the sky area with the mop brush, then use ultramarine to paint round the cloud shapes.

4 Mix ultramarine and burnt umber and drop this in wet into wet for darker clouds. Allow to dry.

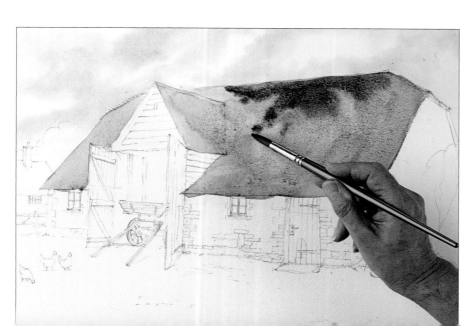

5 Paint a wash of burnt sienna over the whole roof, still using the mop brush, then change to the no. 12 round brush and drop in burnt umber wet into wet.

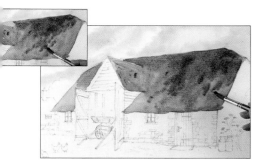
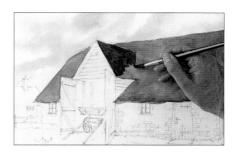

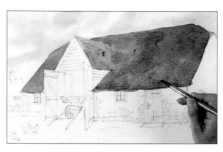

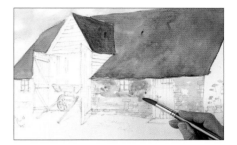

6 Drop in cobalt blue wet into wet, then a stronger mix of cobalt blue with permanent rose added.

7 Drop in olive green to suggest moss on the lower part of the roof.

8 Paint the shadow on the pointed part of the roof with a mix of burnt umber, cobalt blue and permanent rose.

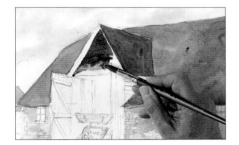

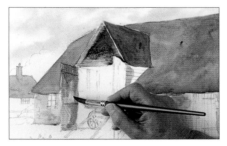

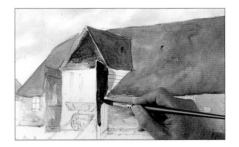

9 Paint the farmhouse in the background with the no. 8 brush and a pale wash of burnt sienna. Drop in cobalt blue wet into wet.

10 Paint the barn walls with a thin wash of raw sienna and the no. 12 brush. Leave some white paper showing.

11 Touch in cobalt blue, wet into wet.

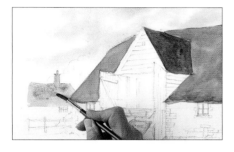

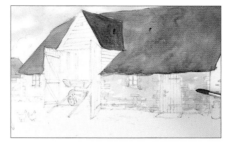

12 Paint the woodwork with a mix of burnt umber and ultramarine, then drop in olive green wet into wet.

13 Paint the barn door with olive green first, then burnt umber and ultramarine.

14 Paint the shaded right-hand door with a dark mix of burnt umber and ultramarine.

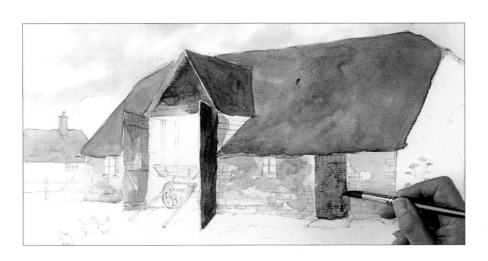

15 Use the same mixes to paint the closed door on the far right. Allow the painting to dry.

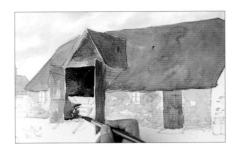

16 Use the dark mix of ultramarine and burnt umber to paint the dark inside the open barn door, starting from the top. Paint round the cart. Lighten the paint lower down towards the floor by adding olive green.

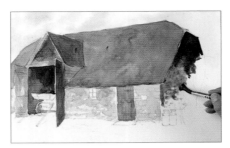

17 Paint the right-hand wooden wall of the barn with the same dark mix, lightening it lower down with olive green as before.

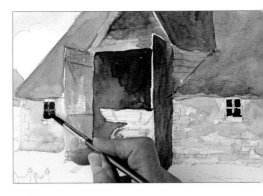

18 Paint the darks in the windows, including the distant farmhouse, with ultramarine and burnt umber.

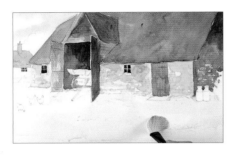

19 Wet the foreground with clean water, then apply a thin wash of raw sienna with the mop brush.

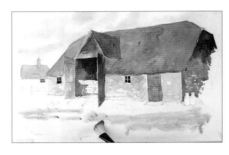

20 Drop in burnt sienna wet into wet, then cobalt blue.

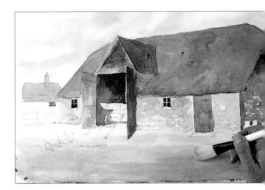

21 Mix burnt sienna with cobalt blue and paint this blue-grey in the foreground.

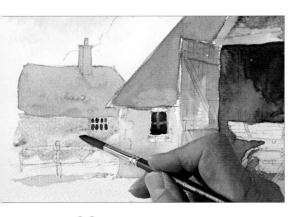

22 Add colour to the wall of the distant farmhouse using the no. 8 brush and burnt sienna.

23 Mix cadmium yellow and olive green and use the no. 12 brush to paint the greenery behind the buildings.

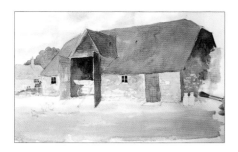

**24** Continue painting greenery in front of the distant farmhouse. Then paint some more on the far right with a mix of cadmium yellow and olive green.

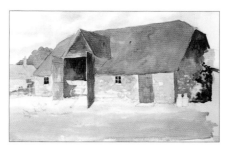

**25** Drop in a mix of Winsor green and burnt sienna wet into wet.

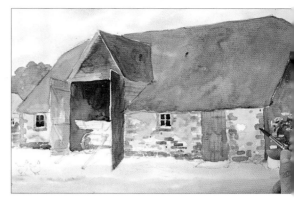

**26** Change to the no. 8 brush and paint some bricks in the barn wall with burnt sienna. Add cadmium red to the mix and paint a few bricks with the brighter colour. Allow to dry.

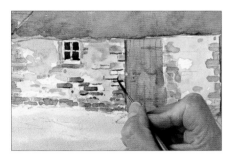

**27** Define the edges of the bricks with the rigger and ultramarine with burnt umber.

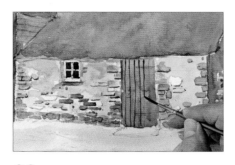

**28** Use a fairly dry rigger brush with the same mix to paint the lines between the planks of the door.

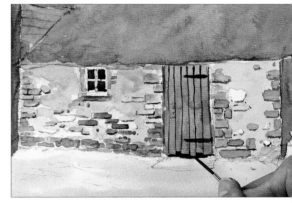

**29** Paint the hinges and the darkness beneath the barn door.

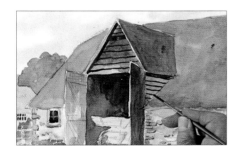

**30** Still using the rigger and the same mix, paint the details of the wood on the gable with uneven horizontal lines.

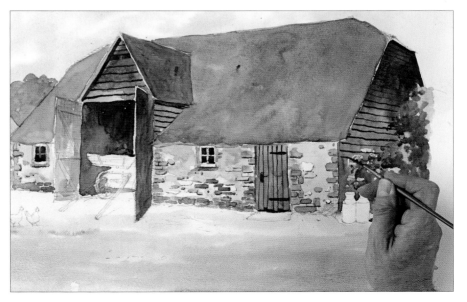

**31** Paint the barn's right-hand wall in the same way, following the laws of perspective.

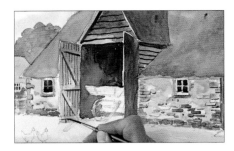

**32** Use the same technique to paint the details of the open door on the left.

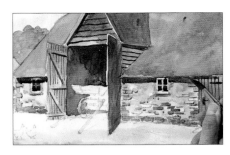

**33** Shade under the eaves with the no. 12 brush and a mix of cobalt blue and permanent rose with a touch of burnt sienna.

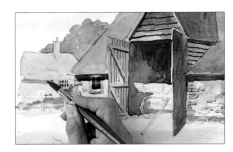

**34** Water down the mix to paint under the eaves of the farmhouse.

**35** Paint the details of the roof tiles with the rigger and burnt sienna in broken horizontal lines.

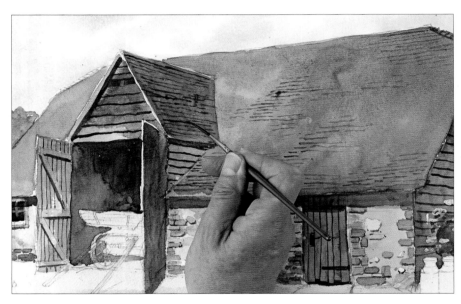

**36** Continue painting the tiles on the side of the gable in the same way.

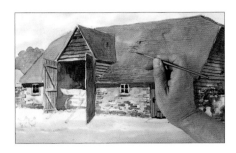

**37** Paint the milk churns with the no. 8 brush and a wash of cobalt blue on the left-hand sides. Allow to dry.

**38** Paint over the milk churns with burnt sienna and ultramarine. Allow to dry.

**39** Paint under the milk churn tops and down the shaded right-hand sides with the rigger and a mix of burnt sienna with ultramarine.

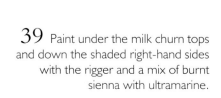

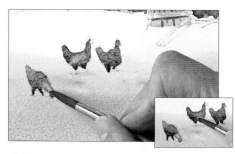

**40** Still using the no. 8 brush, paint the chickens with burnt sienna. Shade their bottom halves with ultramarine and burnt sienna, working wet into wet.

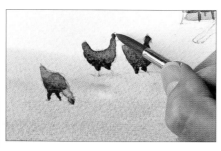

**41** Paint the chickens' combs with cadmium red.

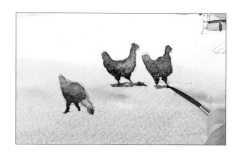

**42** Use the rigger brush with a mix of cobalt blue and burnt sienna to paint the chickens' feet and to add a little shadow underneath them.

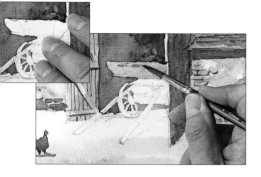

**43** Rub off the masking fluid with clean fingers. Paint the top of the cart with cobalt blue and the no. 8 brush, then drop in burnt sienna wet into wet to weather it.

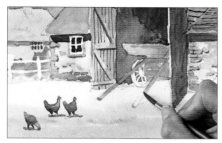

**44** Paint the lower part of the cart with a thin mix of cadmium red.

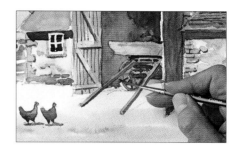

**45** Mix ultramarine and cadmium red and use the rigger to paint the shaded parts, then paint the wheel with burnt sienna.

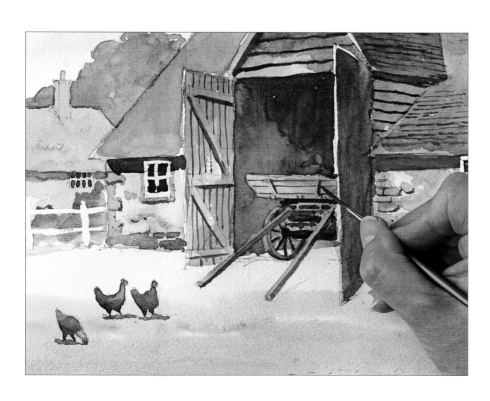

**46** Use a strong mix of ultramarine and burnt umber to paint the dark between the spokes and other details.

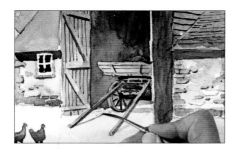

**47** Add shadows under the cart shafts with the rigger and cobalt blue with burnt sienna.

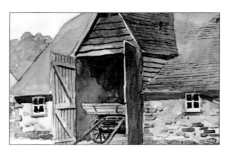

**48** Paint shade over the windows with the same mix.

**49** Add colour to the fence on the left with a thin wash of olive green and the no. 8 brush.

**50** Mix burnt umber with olive green and use the rigger to paint the shaded parts of the fence.

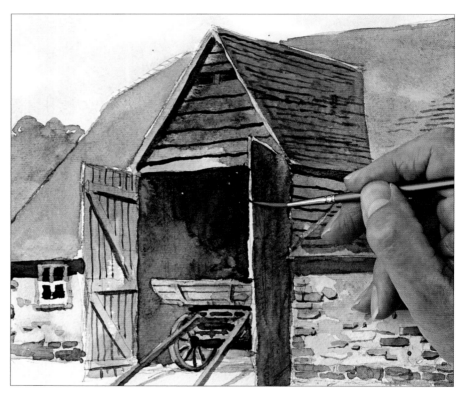

**51** Use watered down olive green to go over the white lines left at the edges of the gable and the highlights on the doors.

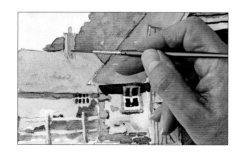

**52** Darken the farmhouse chimney with the rigger and burnt sienna.

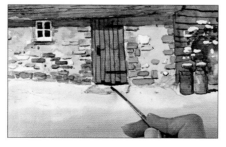

**53** Paint the detail of the doorstep in the same way.

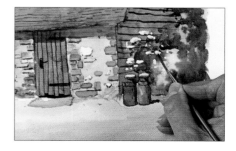

**54** Add shadow to the cow parsley with the rigger and cobalt blue.

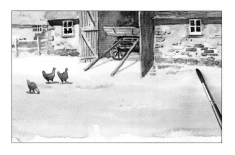  

**55** Use the no. 8 brush and burnt sienna with the dry brush technique to create texture along the ground.

**56** Paint the edges of the ridge tiles along the barn roof with burnt sienna.

**57** Finally mix Winsor green and burnt sienna and use the rigger to paint stalks and other details around the cow parsley.

*The finished painting.*

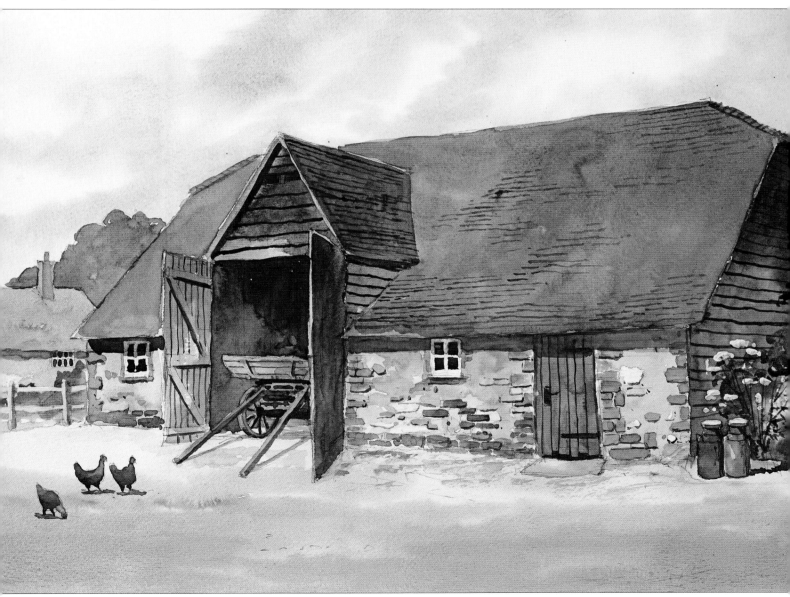

## AFTER THE HARVEST
*50 x 33cm (19¾ x 13in)*

*This farm has just grown and grown, probably starting with the main barn and granary, with the other smaller buildings added on when needed.*

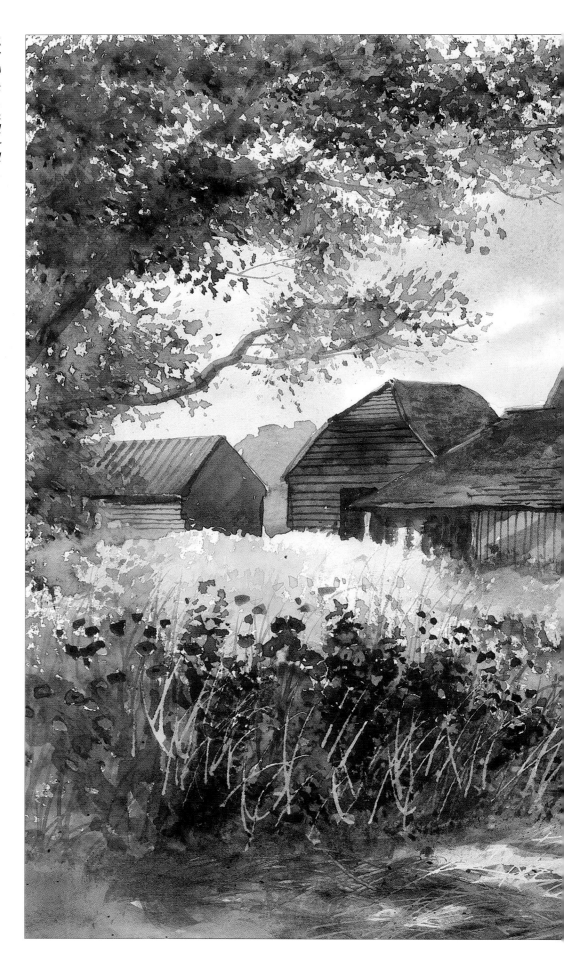

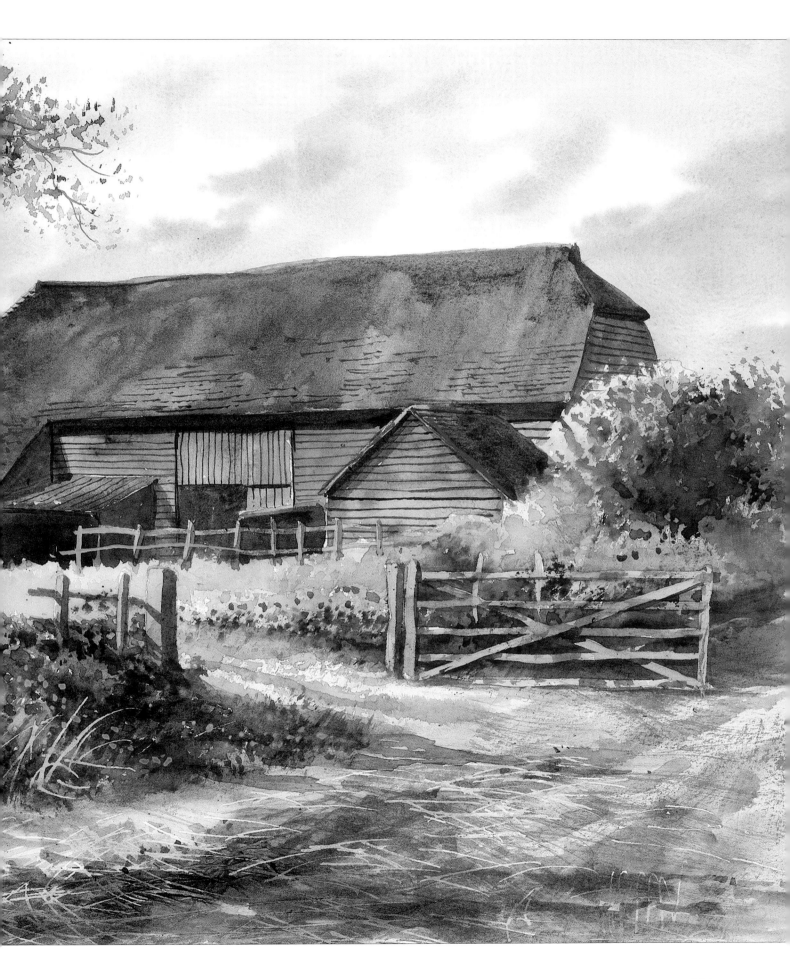

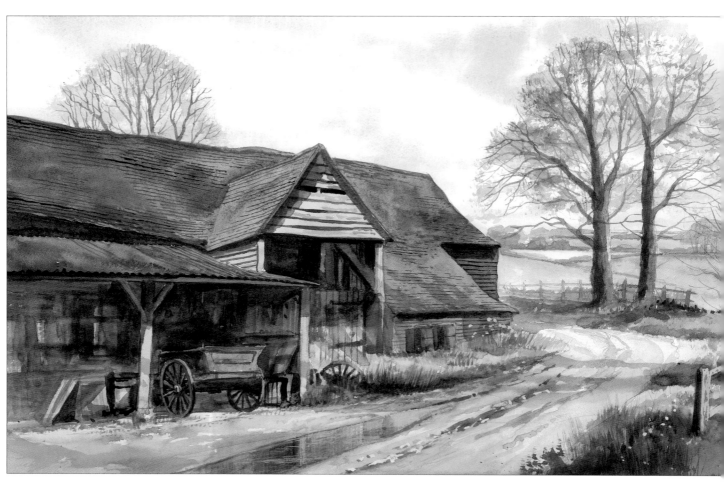

THE WAGON SHED
*54 x 34cm (21¼ x 13³/₈in)*

RUSTIC DORSET
*52 x 35cm (20½ x 13¾in)*

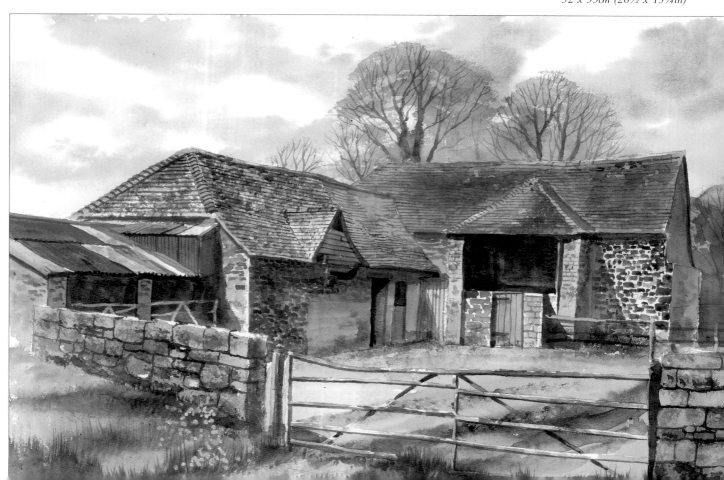

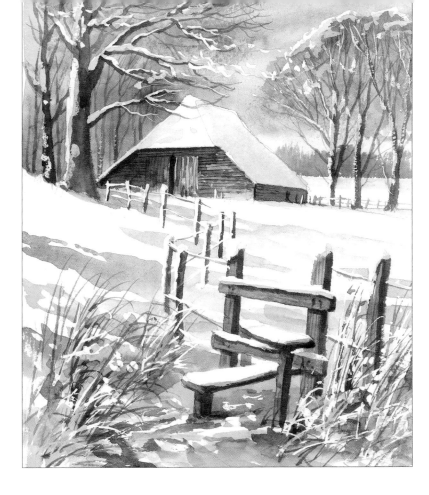

## WINTER SHELTER
*23 x 28cm (9 x 11in)*

*The stile and fence lead the viewer into the painting, towards the shelter of the barn.*

## DAY'S END
*48 x 34cm (19 x 13³/₈in)*

*Long, cool shadows on the lane contrast with the warmth of the late evening sun on the side of the barns.*

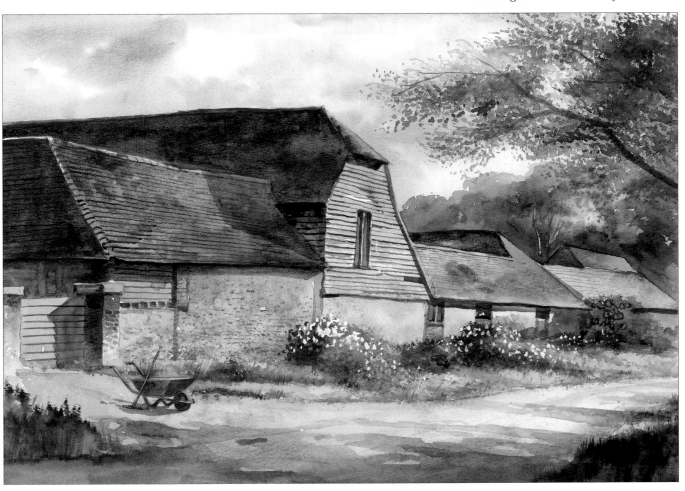

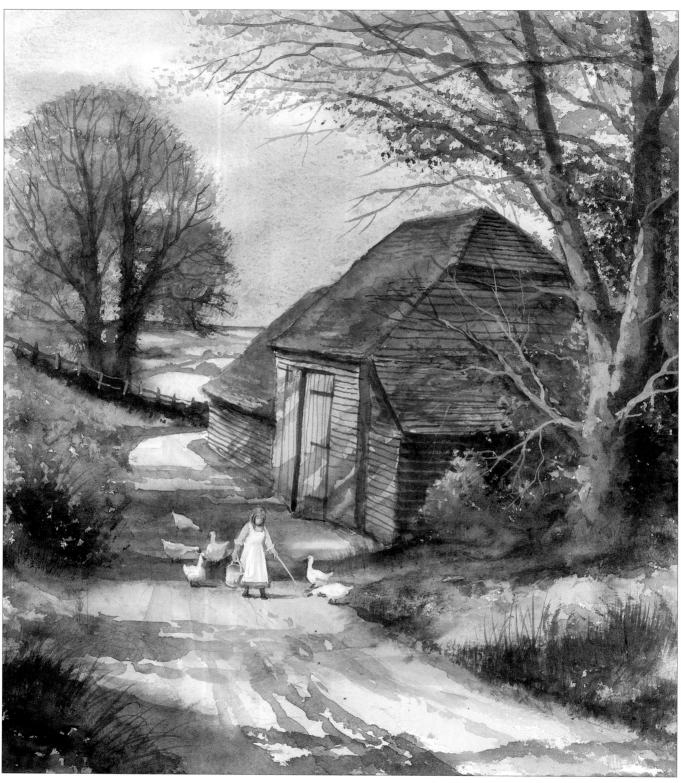

## THE GOOSE GIRL
*31 x 35cm (12¼ x 13¾in)*

*Adding life to a scene can change the whole interpretation of the subject. No longer just a barn, but now a working farm with a young girl struggling to keep her gaggle of geese in order.*

## CHICKENS ON THE VERGE
*35 x 46cm (13¾ x 18¹/₈in)*

*To liven up this farmstead, some chickens and ducks were added to the grass verge. The old barn is made to look more rustic by removing some of the planks from the walls.*

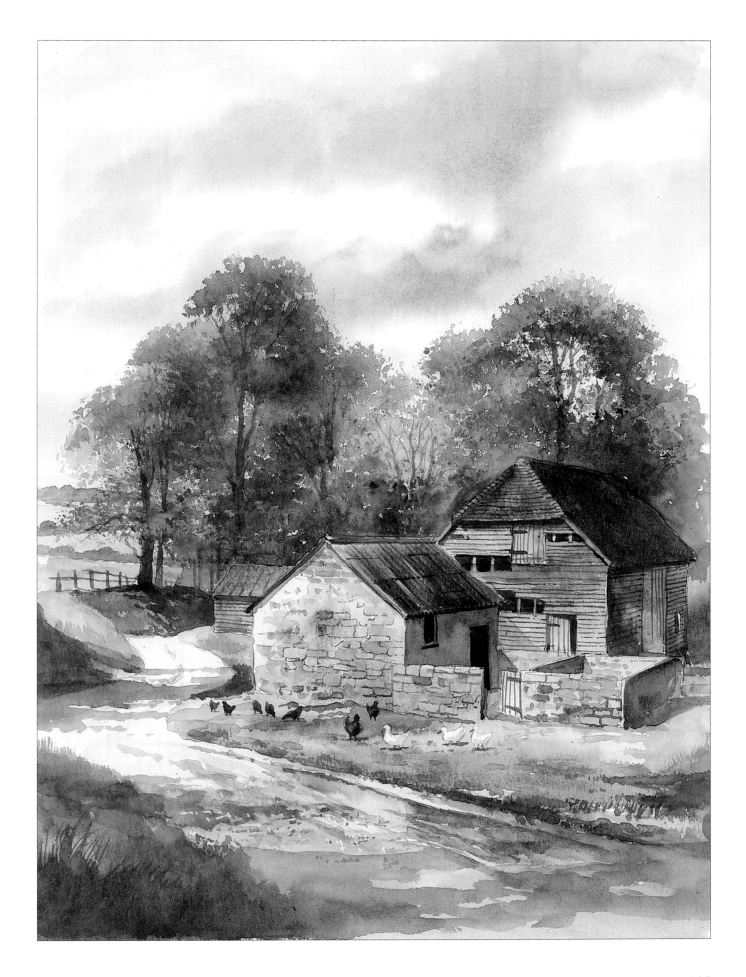

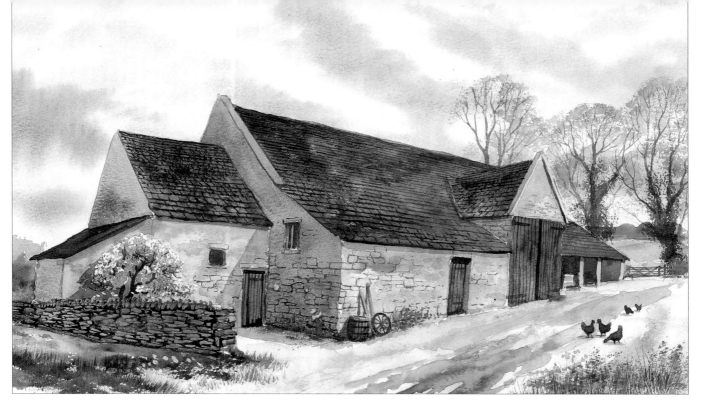

SPRING TIME ON THE FARM
*48 x 34cm (18⅞ x 13⅜in)*

*Opposite*
MOUNTAIN VALLEY BARN
*34 x 54cm (13⅜ x 21¼in)*
*A plastic card was used to scrape out the valley
sides and the rocks in the foreground.*

GATHERING THE GEESE
*42 x 28cm (16½ x 11in)*

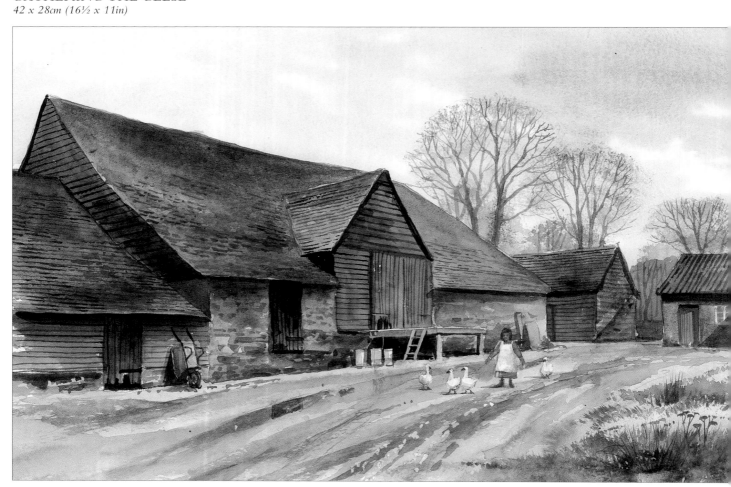

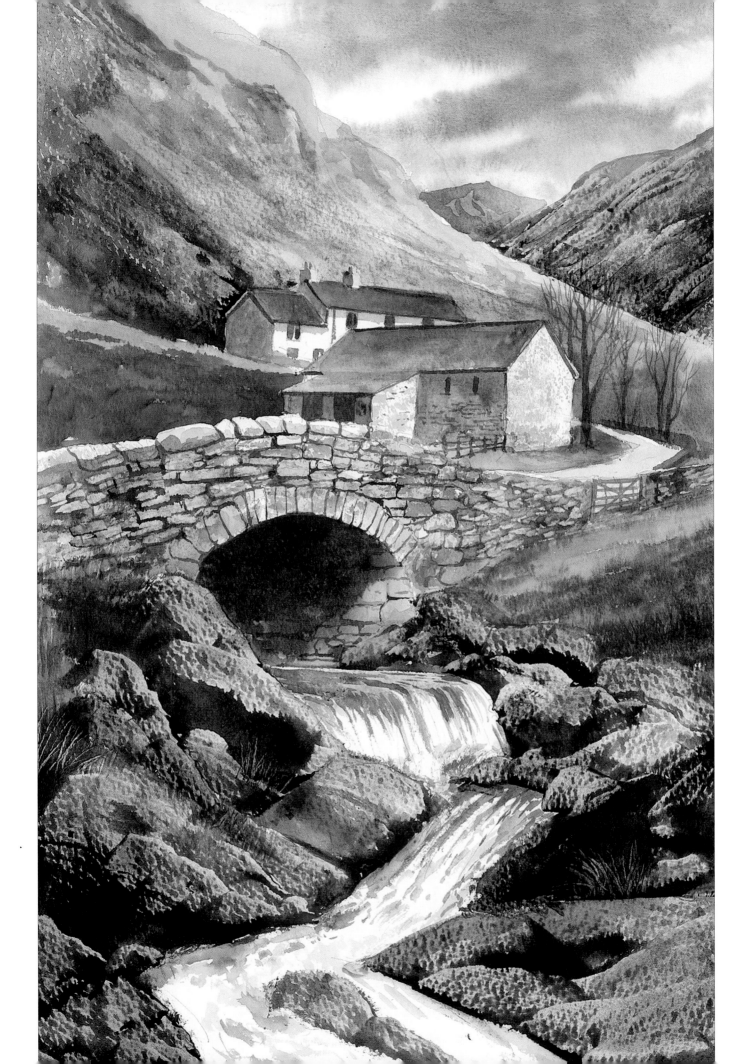

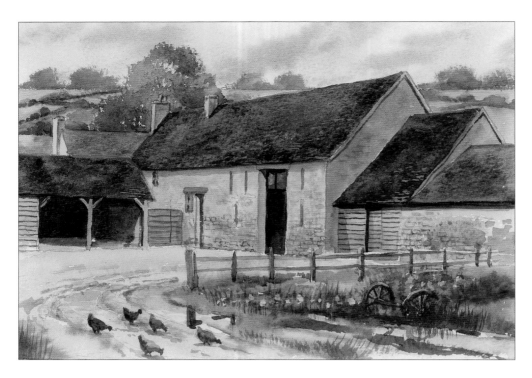

## SWIFTS BARN
*28 x 20cm (11 x 7⅞in)*

*Set in the rolling hills of the Cotswolds, Swifts Barn is not a grand building but part of a small farmstead with open cart sheds and cattle shelters on either side of the barn. The famous Cotswolds stone colour is tricky to achieve; use a cadmium orange base colour and drop in mixtures of permanent rose, burnt sienna and cobalt blue to tone this down.*

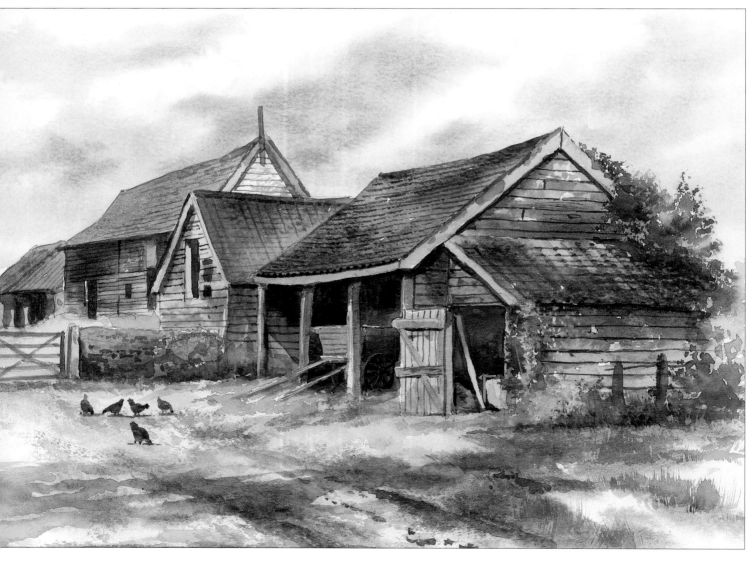

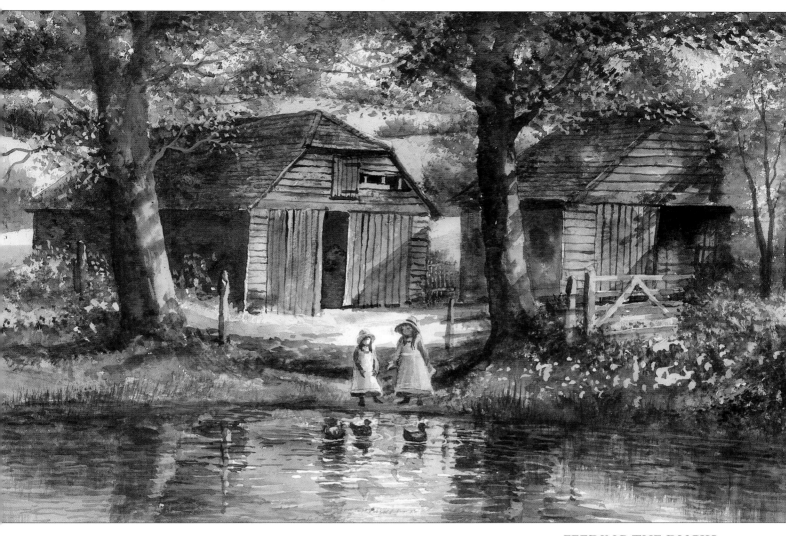

FEEDING THE DUCKS
*39 x 25cm (15³/₈ x 9⁷/₈in)*
*The small children feeding the ducks provide a foreground interest but the main subject of the painting has to be the old barns in dappled sunlight.*

*Opposite*
SUFFOLK BARNS
*37 x 29cm (14½ x 11½in)*

*The cart, the open door and the chickens feeding all add to this busy farmyard setting.*

# American Barn

The High Country of North Carolina is the home of many beautiful rustic barns scattered amidst the Blue Ridge Mountains. This demonstration is based on a typical example of a barn from this area: a wooden structure weathered and seasoned under a rusting tin roof, with an old cart sitting amongst the flowers and long grasses in the meadow.

YOU WILL NEED

Not paper, 38 x 56cm (15 x 22in)

Masking fluid and ruling pen

Colours: French ultramarine, burnt umber, aureolin, cobalt blue, indigo, Indian yellow, green gold, permanent rose, burnt sienna, olive green

Brushes: large mop, no. 12 round, 13mm (½in) flat brush with shaped, clear acrylic resin handle, no. 8 round, rigger

1 Mask the flowers in the foreground and the cartwheels with a brush protected beforehand by rubbing it on a bar of soap. Then use a ruling pen to mask the grasses.

2 Wet the sky area with a mop brush, then use the no. 12 brush to drop in ultramarine, painting round cloud shapes.

3 Drop in burnt umber and ultramarine wet into wet.

4 Wet the area of the trees on the right-hand side, behind the barn. Paint the trees with aureolin and cobalt blue, then drop in aureolin wet into wet.

**5** Still working wet into wet, drop in a darker green mixed from indigo and Indian yellow.

**6** Scrape out tree trunks from the green area using the specially shaped clear brush handle.

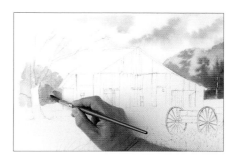

**7** Paint the trees on the left-hand side with cobalt blue and aureolin first, then drop in Indian yellow.

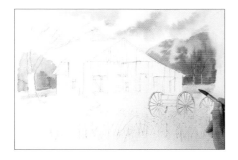

**8** Begin to paint the grass coming forwards from the background trees with a mix of cobalt blue and aureolin, on both sides of the barn.

**9** Wet the area just below this, and drop in Indian yellow wet into wet.

**10** Still working wet into wet, drop in indigo and Indian yellow and let it bleed into the background.

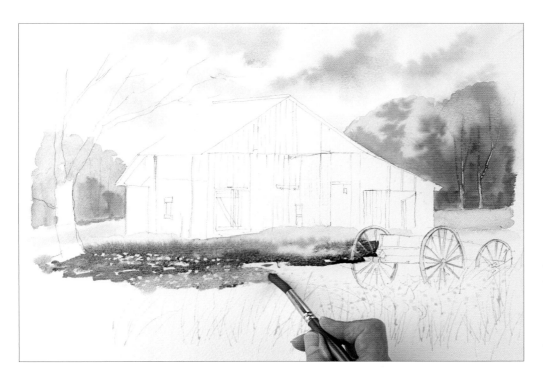

**11** Continue painting towards the foreground with a lighter mix of the same colours.

 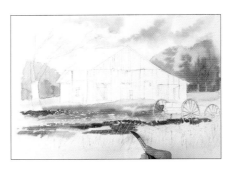 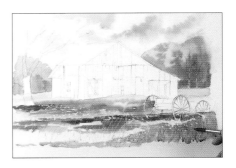

**12** Blend in aureolin wet into wet and paint right down to the bottom of the painting.

**13** Drop in the dark indigo and Indian yellow mix in horizontal bands.

**14** Add more Indian yellow to the dark green mix and paint this along the foreground as shown. Allow to dry.

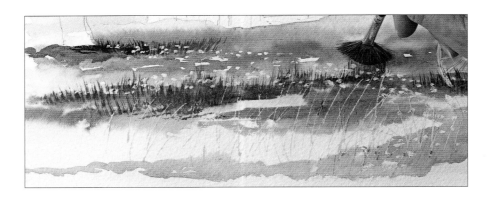

**15** Take a fan brush and flick up grasses with the indigo and Indian yellow mix, working wet on dry.

**16** Use the no. 12 brush and brighten the lighter greens with a glaze of green gold in places. Allow the painting to dry.

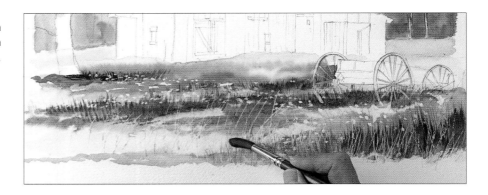

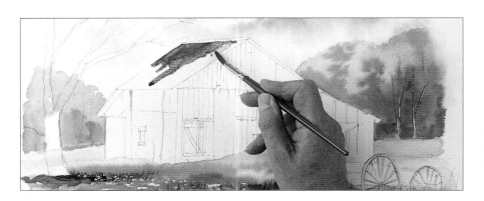

**17** Begin to paint the barn roof with cobalt blue, permanent rose and burnt sienna with the no. 8 brush. Vary the mix as you paint.

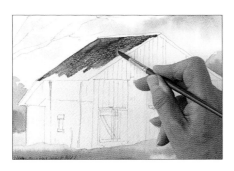

**18** Add burnt sienna on its own – this colour granulates when it meets the others, creating an ideal rusty texture.

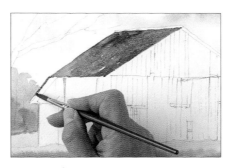

**19** Paint more burnt sienna down the edge of the lean-to.

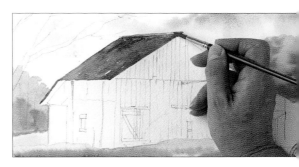

**20** Paint cobalt blue on the ridge of the barn roof. Allow to dry.

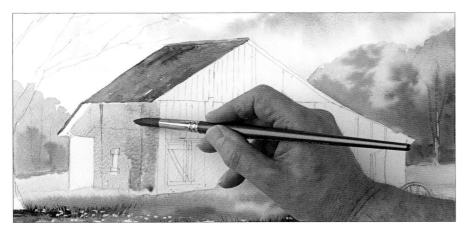

**21** Mix cobalt blue with a touch of burnt sienna and paint the barn's side wall with the no. 12 brush.

**22** Drop in raw sienna wet into wet, and allow to dry.

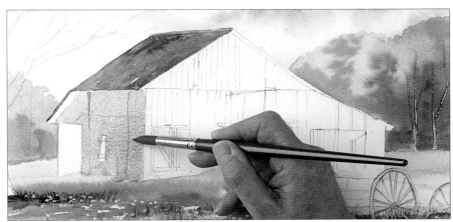

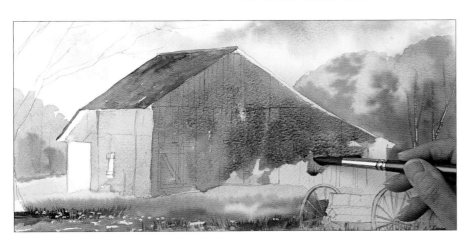

**23** Paint the front wall with a stronger mix of cobalt blue and burnt sienna.

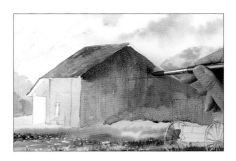

24 Working wet into wet, paint burnt umber and cobalt blue under the roof and stroke it down the wall. Allow to

25 Mix cobalt blue and burnt sienna to paint the shadowed parts of the side wall.

26 Paint the darkest parts such as the open door with the no. 8 brush and ultramarine with burnt umber.

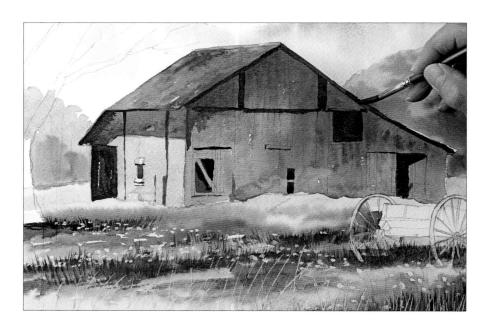

27 Continue painting the large, dark details of the barn with the same brush and paint mix.

28 Change to the rigger brush and use the same mix to paint the finer details such as the corrugation on the left-hand wall.

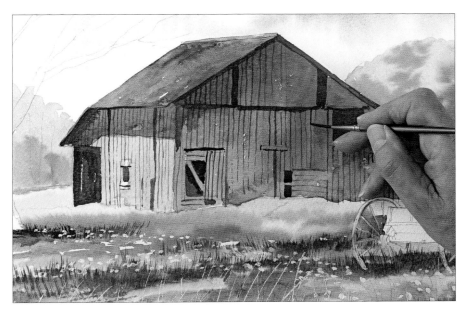

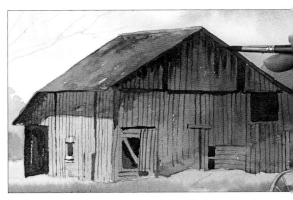

**30** Paint the dark under the eaves with the no. 8 brush and burnt umber with a touch of ultramarine.

**29** Use the rigger and the burnt umber and ultramarine mix to paint the corrugation on the front of the barn.

**31** Paint the details of the tin roof with the rigger brush and the same mix.

**32** Mix cobalt blue and burnt sienna and use the no. 8 brush to paint the cart.

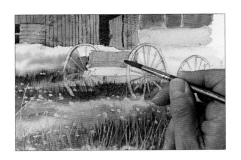

**33** Use a darker mix of cobalt blue and burnt sienna to paint the shaded areas of the cart, over the masking fluid. Allow to dry.

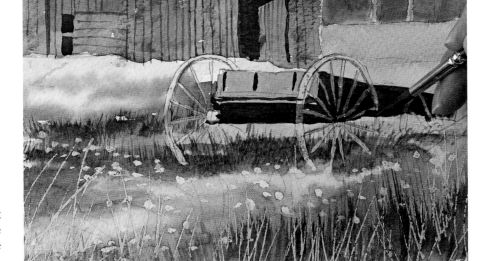

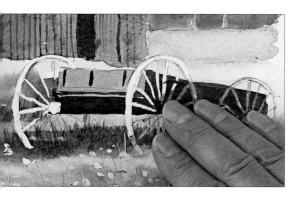

34 Remove the masking fluid from the cart with clean fingers.

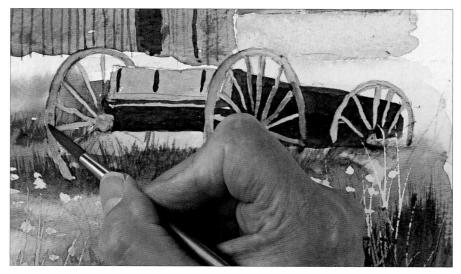

35 Paint the cart wheels with the no. 8 brush and burnt sienna.

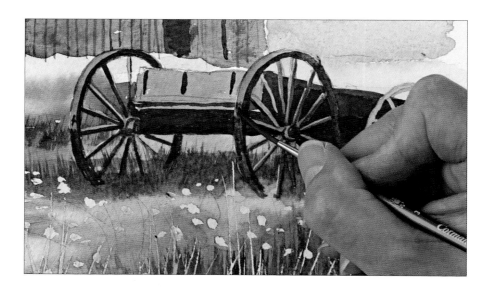

36 Working wet into wet, use the rigger and burnt umber and ultramarine to paint the shaded parts of the wheels.

37 Paint the tree on the left with the no. 8 brush and burnt umber with ultramarine.

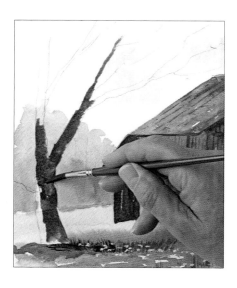

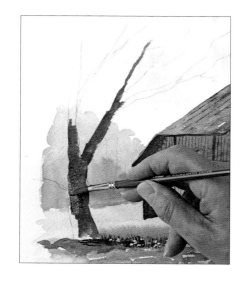

38 Drop in raw sienna wet into wet.

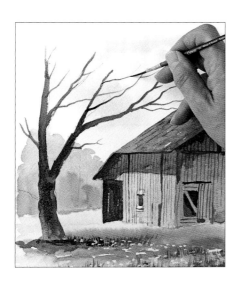

39 Extend the branches of the tree with the no. 8 brush, then change to the rigger to paint the finer branches and twigs.

40 Mix cobalt blue with cadmium yellow and still using the rigger brush, paint trees in the distance.

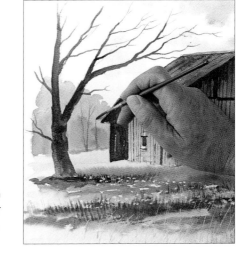

41 Paint distant trees on the right in the same way, extending the lines you scraped out earlier.

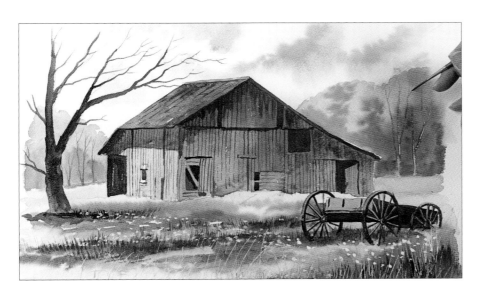

42 Use the mop brush with its bristles separated and olive green to dab in foliage on the left-hand tree. Allow to dry.

**43** Stipple on a mix of Indian yellow and indigo for the darker parts of the foliage, working wet on dry.

**44** Use the 13mm (½in) flat brush to flick up grasses in the foreground with the same dark green mix. Scrape out lighter grasses with the clear, shaped handle.

**45** Use the rigger brush and the same dark green to paint more grasses in the foreground.

**46** Remove the masking fluid from the foreground.

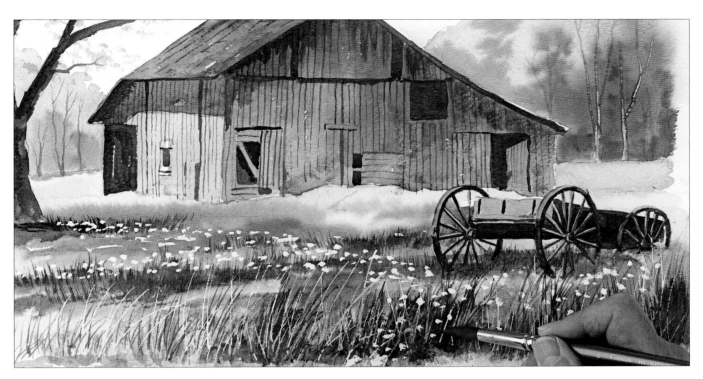

47 Use the no. 12 brush and green gold to go over the foreground grasses.

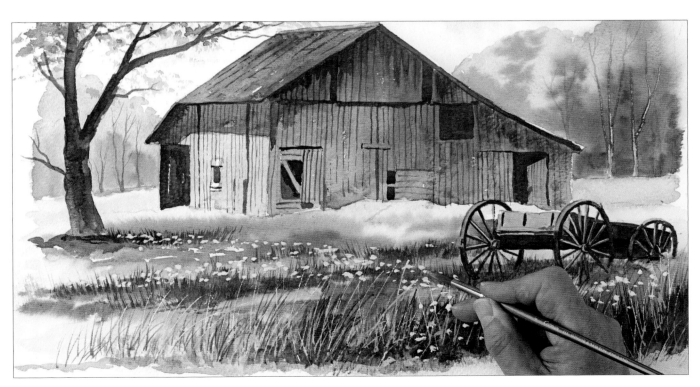

48 Change to the no. 8 brush and paint the flowers with cadmium yellow.

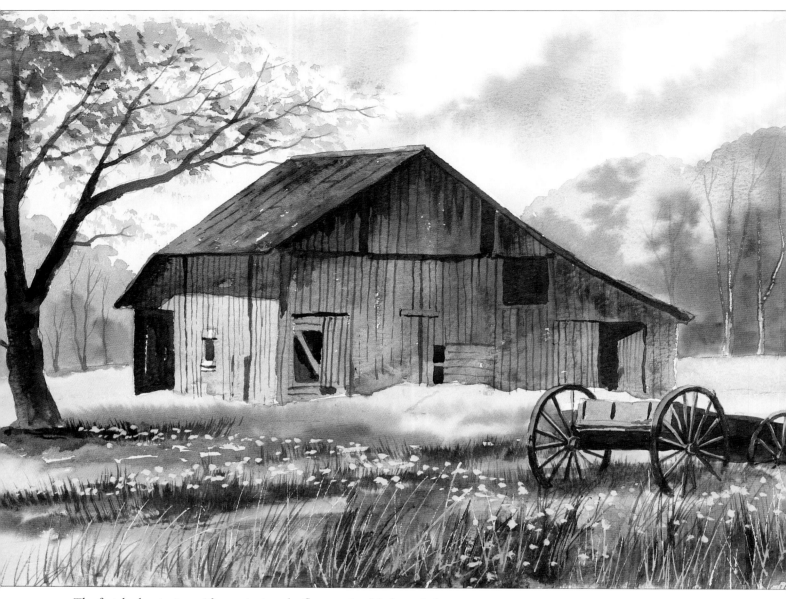

*The finished painting. After painting the flowers, I added a pale burnt sienna wash over the highlights of the barn that had been left white.*

*Opposite*
GONE FISHIN'
*33 x 43cm (13 x 17in)*
*For some people this is a dream setting, fishing in a cool mountain stream with an old rustic barn to keep you company.*

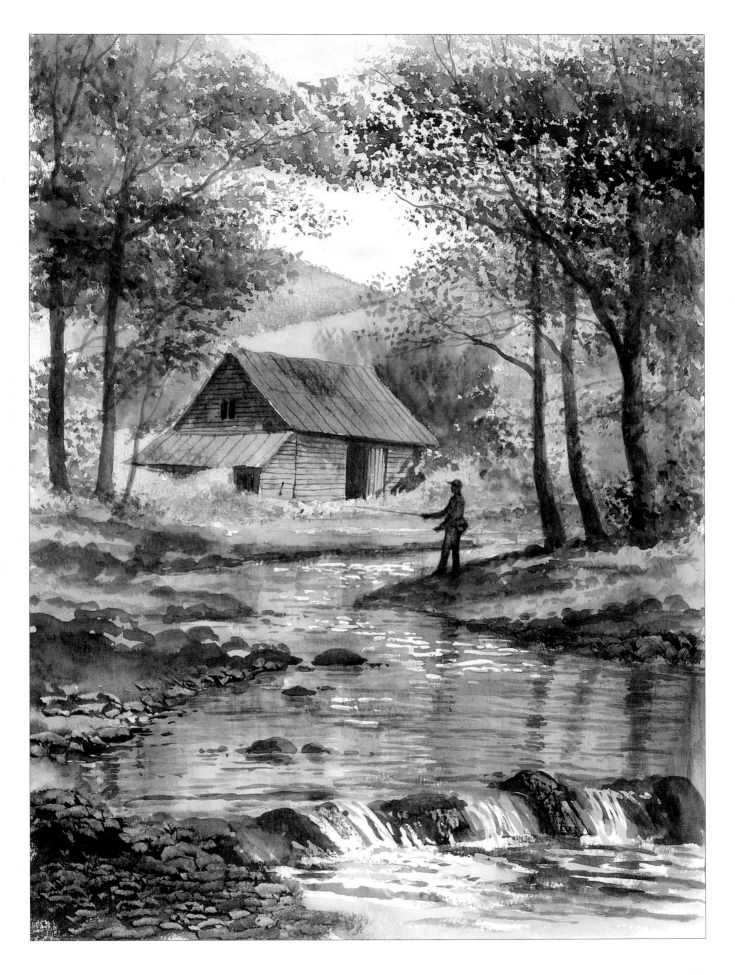

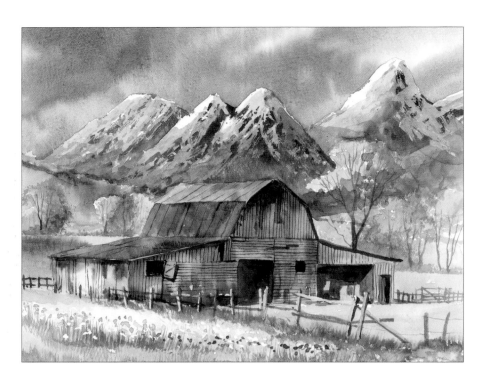

## SHADOW MOUNTAIN
*31 x 26cm (12¼ x 10¼in)*

*This painting was created using a selection of reference photographs. The rusty orange and red of the old tin roof contrast strongly with the dark, cool colours of the mountain range behind. I used masking fluid to create the snow on the mountains and the fence and flowers in the foreground.*

## HARD DAY'S WORK
*53 x 35cm (20⅞ x 13¾in)*

*Keeping the background trees and the barn walls dark highlights the sunlight on the barn roof and the pick-up truck. The tractor could be positioned in another setting and work equally well.*

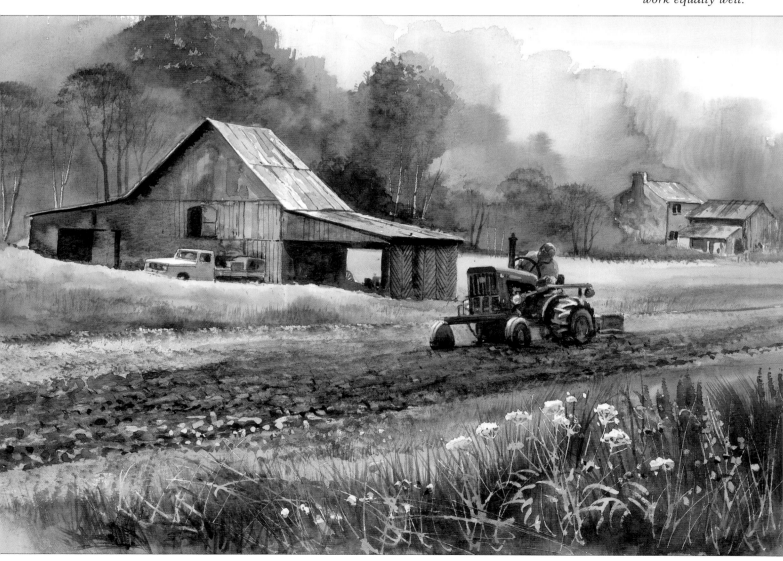

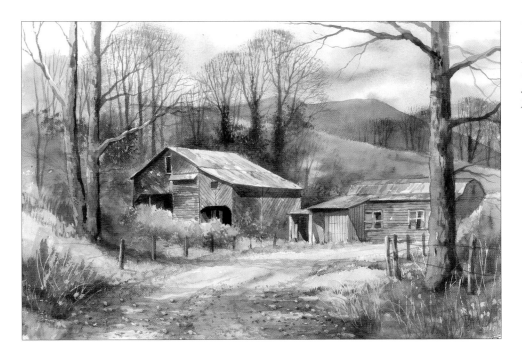

## FADED RED BARN
*50 x 35cm (19¾ x 13¾in)*

*Red barns are not rusted barns, but painted red. The grey sections are where the paint has flaked off, exposing the bare wood underneath.*

## AFTER THE STORM
*42 x 34cm (16½ x 13³/₈in)*

*The herringbone pattern created by the wooden planks is a unique feature of many barns in North Carolina. These influences must date back to the early settlers of America and their heritage from different parts of Europe.*

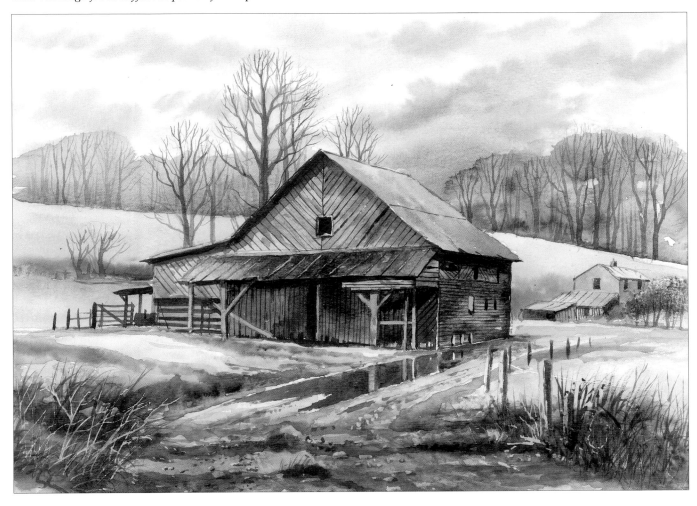

## WOODLAND RETREAT

*53 x 34cm (20⅞ x 13³/₈in)*

*Hidden away in the woods, this rustic farm has drifted into a state of graceful decay; with a bit of luck it might last a few more winters. The strong shadows on the track and the foreground trees help to frame this delightful scene.*

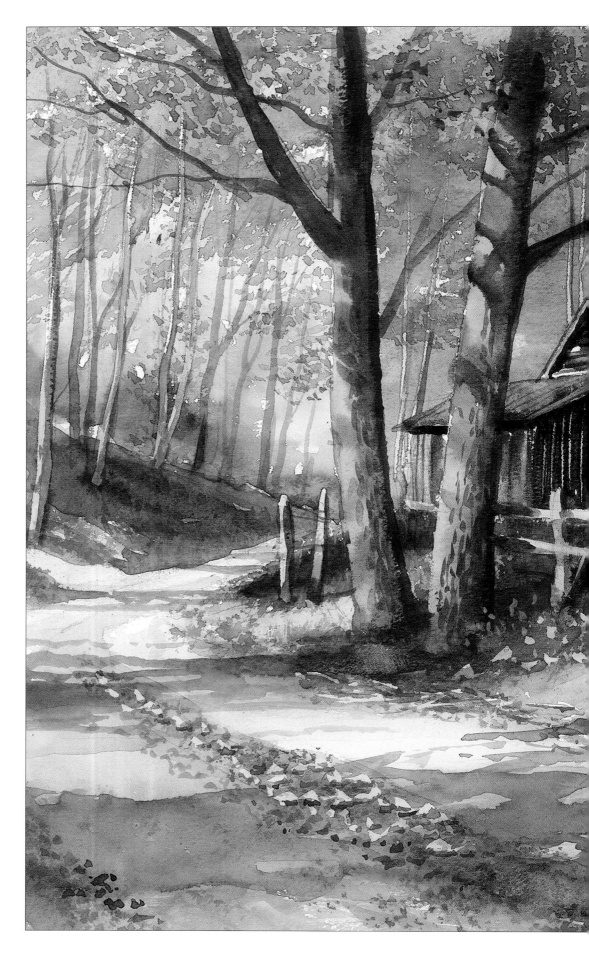

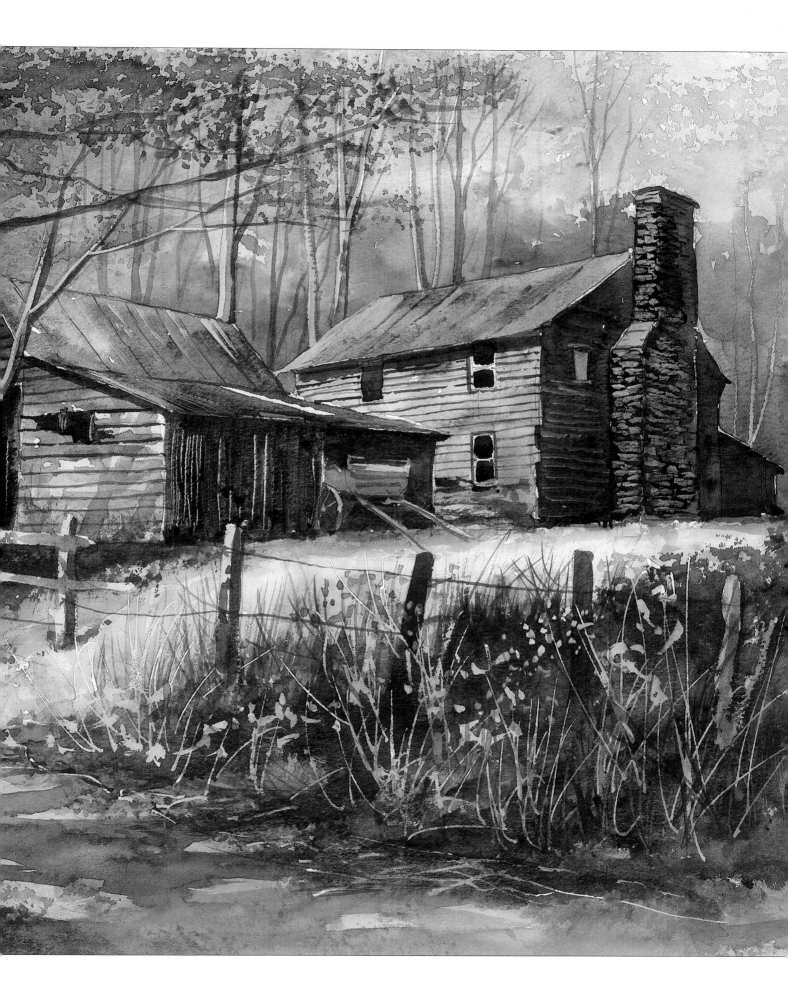

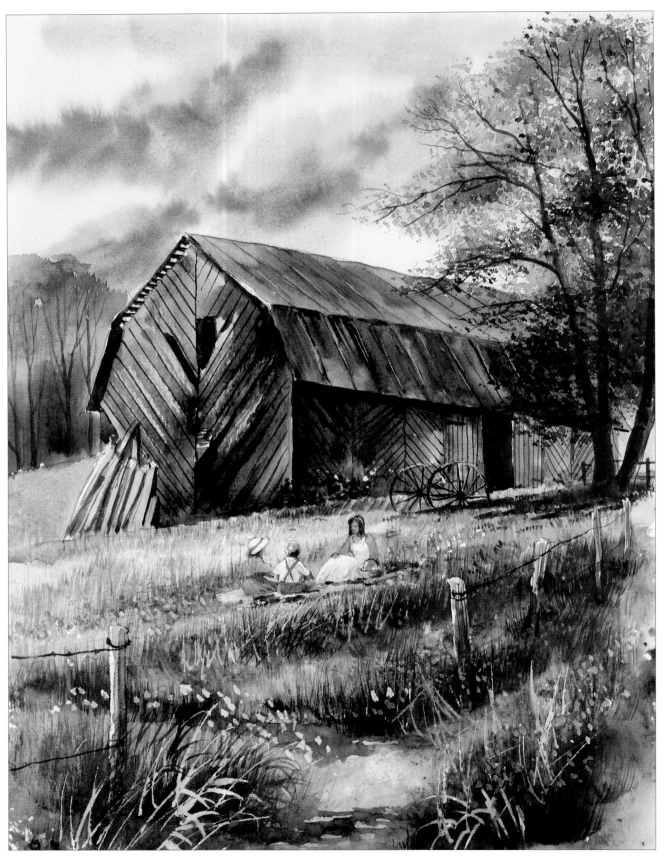

## PICNIC AT THE OLD BARN
*32 x 42cm (12⁵/₈ x 16½in)*

*This barn has a very distinctive look: the wooden planks on the walls are placed diagonally to create a herringbone pattern. Adding life to a painting can evoke memories or prompt a story.*

## ANOTHER WINTER

*28 x 22cm (11 x 8⅝in)*

*Winter can be a bleak time and a barn offers much needed shelter. I have used a limited palette for this painting: ultramarine, cobalt blue, burnt umber, burnt sienna and permanent rose.*

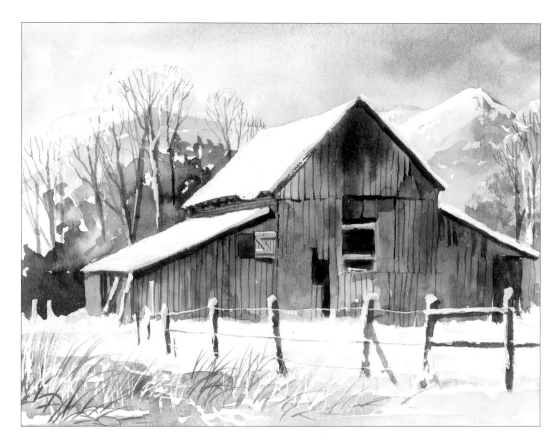

## UNDER COVER

*30 x 20cm (11¾ x 7⅞in)*

*This old barn offers lots of scope for the wet into wet technique on the roof and the barn walls. The covered wagon adds a rustic finishing touch.*

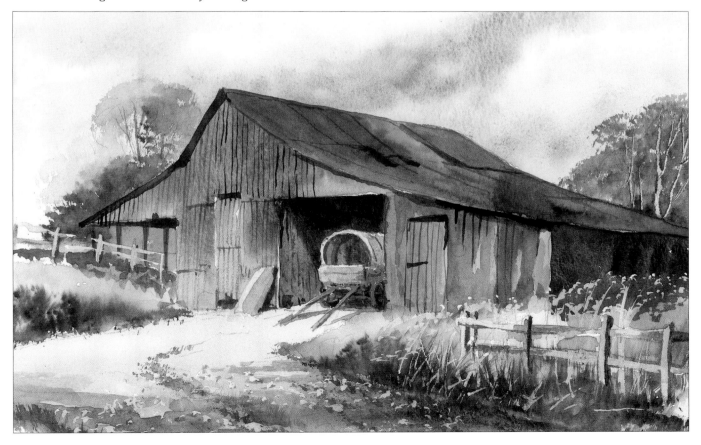

# Index

TERRY HARRISON